DISORDER MODEL

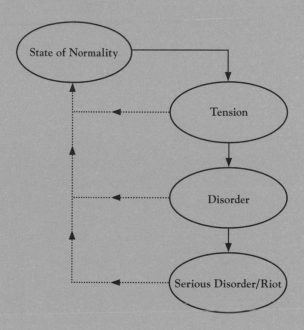

Figure 1.

SARAH PICKERING

SARAH PICKERING
EXPLOSIONS, FIRES, AND PUBLIC ORDER

ESSAY BY KAREN IRVINE

aperture

INCIDENT CONTROL

If every strategy today is that of mental terror and of deterrence tied to the suspension and the eternal simulation of catastrophe, then the only means of mitigating this scenario would be to make the catastrophe arrive. It is God who through his cataclysms unknots the equilibrium of terror in which humans are imprisoned. Closer to us, this is what terrorism is occupied with: making real, palpable violence surface in opposition to the invisible violence of security. Besides, therein lies terrorism's ambiguity.

—Jean Baudrillard, *Simulacra and Simulations*

Sarah Pickering's photographs jar our sense of security and illuminate the ways in which we cope with traumatic events that are beyond our control. Her pictures depict environments and events crafted for the purpose of training policemen, firemen, and soldiers for calamities such as terrorism, civil unrest, fire, and war. By exposing the absurdity and controlled nature of these environments, Pickering's images reveal our predilection to deflect fear by trying to anticipate and plan for it—and our tendency to process it by turning it into narrative. Ultimately Pickering's photographs raise questions about the efficacy of preparedness and hint at the psychological effort needed to combat and recover from trauma—the struggle to live with the anxiety, the invisible violence, that accompanies security.

Pickering's Public Order (2002–5) photographs depict various locations used to train specialists from the British Police Services.

Charged with maintaining public order, the officers specifically respond to terrorism and mayhem such as football riots, protests, and altercations involving armed suspects. The training locations are completely fabricated, large-scale backdrops that simulate urban environments. The largest of these, Denton, where Pickering shot most of her pictures, is a huge network of fake streets and cinder-block facades, with all of the hallmarks of a mid-size British working-class town, including a football stadium, a nightclub, shops, apartment complexes, and a Tube station. Less realistic than a film set, Denton is staid and cartoon-like in its reductive organizational structure and general cleanliness, contradicting the reality of a riot or terrorism and their inherent disarray.

Pickering's pictures of Denton and the other training centers are straightforward, even clinical, mirroring the unembellished design and pragmatic nature of the locations. Pickering made the photographs before and during her graduate studies at the Royal College of Art in London in the early 2000s. At one point in her undergraduate career she had considered becoming a forensic photographer. She was ill-suited for that type of work, however, since gruesome scenes make her squeamish. But the idea allowed her to recognize that direct, documentary photography excited her more than the heavily staged large-scale tableaux that were very popular at the time.[1] More like the German students of Bernd and Hilla Becher, including Candida Höfer, Thomas Ruff, and Thomas Struth, who make deadpan work of everyday people and places, Pickering makes full use of

1. Sarah Pickering, email correspondence with the author, April 14, 2009.

the transformative reduction of information that is photography. She is fascinated by the potential of the camera to at once record the real and abstract it. Unlike the German photographers, however, she is drawn to a particular type of reality—that of the simulation.

Pickering's photographs are documentary, yet complicated by the fictitious, theatrical nature of the subjects she records. Like the photographs of An-My Lê and Geissler/Sann, which document rudimentary, simulated environments used to train soldiers for war, Pickering's pictures not only record the physical structure of the place, but also the aspects that reveal its artifice and purpose as a location designed to mentally indoctrinate the men and women in training. In Denton, street signs, shop names, and other details betray a subtle, but deliberate positioning of the identity of the imagined perpetrators. The inclusion of signs for unemployment offices, nightclubs, graffiti, and fast-food establishments suggest a certain type of person—young, male, disenfranchised, and unemployed all among the possible defining traits. This, for Pickering, amounts to social stereotyping, at once disturbing and somewhat strange, as dissenters clearly are not always of this type.[2] The G20 summit protests in London in 2009, for example, included many academics, students, and environmentalists in addition to the usual anarchists.[3]

Through her contacts at the Metropolitan Police Service, Pickering gained access to the Fire Service College, one of the largest fire training centers in the world, where she produced two subsequent bodies of work: Fire Scene (2007) and Incident (2008). The Fire Scene pictures document fires in containers outfitted as home

environments and then burned to train forensic teams and crime scene investigators. Pickering photographs just as the fire catches, and there is a captivating beauty in the blaze and a thrilling quality in the danger it represents. These images also suggest power, by giving the impression of being able to stop the fire mid-stream, creating a fantasy of fending off the frightening and unpredictable flames.

Even more detailed than the fake cities in Public Order, the Fire Scene interiors are staged as elaborate, crammed domestic spaces, deliberately heavy with narrative. Each fire has been designed according to a specific cause, such as a heater being used to cook a meal, or a glue-sniffing escapade gone wrong. The fire investigators must decipher the origin. As she was in Denton, Pickering is bemused, this time by the stereotyping she observes in the set designs in the forensics unit of the Fire Service College. The spaces are typically untidy, chaotic environments that include items such as empty bottles of alcohol and worn furniture that suggest that the occupants are unruly and probably low income.

The fictitious troublemakers profiled in the Public Order and Fire Scene sets are not inherently deviant. Their actions are placed in the context of a hardscrabble working-class environment, and are therefore the result of circumstance, making them perhaps less threatening to the trainees than if disobedience were portrayed as a random, essential trait of the group. This need to humanize the trauma, to make sense of it, might promote more empathy on the part of the police and forensic trainees. On

2. Ibid.

3. Landon Thomas, Jr., "Protesters Block London's Financial District," *New York Times*, April 2, 2009, p. A14.

the other hand, if the identities and locations are experienced as existing in the realm of the Other, could it be that the artifice, while helpful in simulating real disaster, also distances it? This dilemma raises the question of translation, and how well all of this preparation will serve the trainees under the stress and psychological trauma of a real situation.

Most people confront trauma with a fight-or-flight response, by either trying to control it or repressing it. Pickering grew up with a mother who did the former; she always kept a disaster preparedness manual at the ready and obsessively checked that appliances were turned off before leaving the house. Pickering also clearly remembers a nuclear attack warning signal at her grade school being tested from time to time. She says she always felt keenly aware of the possibility of things going completely awry.[4] Once while at a Public Order Training Center she found a flow chart outlining disaster escalation (on the endpaper of this book). This attempt to organize and make sense of something chaotic, struck her as inherently paradoxical.[5] But it certainly reveals that trying to make something knowable, understandable, and therefore, avoidable is a very human thing to do.

For her Explosion (2004–present) photographs, Pickering went to sites where fake bombs are deployed for military personnel, and for movie executives who are interested in buying pyrotechnics. Manufactured by some of the companies that make explosives for James Bond and war films, the bombs are built for use in military training exercises. Pickering captures the explosions as they are detonated in demonstrations, isolated in a benign landscape void of people

and infrastructure. Made to imitate artillery, napalm, and land mines, these explosions are controlled, and like toys or fireworks, are much smaller in scale than their real-world counterparts. The pictures Pickering makes of them are alluring. The clouds of smoke, all in different shapes and colors, hover a few feet above the ground as if a magic trick has just occurred, capturing a fleeting occurrence that is mysterious and beautiful, and odd in its lack of context.

The Explosion pictures document the literal theater of war—the detailed level of artifice used to prepare men and women for combat on the front lines. They also reveal the minutiae of packaging war as entertainment. The beauty of the pictures lies in their perverse seductiveness, and this attraction underscores the distance most of us have from real combat. Pickering's Explosion images, by distilling an aspect of the war that is a fiction, question the reliability of seemingly objective historical accounts, such as news reports and photographs that influence how war is communicated and remembered. By extension they question how we come to know what we know about it. We learn about war from a variety of sources, from history books, first-hand accounts, news media, and movies, all of which can get confused and merged in our minds as memory.

The dual purpose of the explosives—training and reenacting—forms a fitting parallel to how we cope with trauma, a process of both anticipation and reconciliation. Until the advent of modern psychological treatment, many societies used theater and ritual to deal

4. Pickering, email correspondence, April 14, 2009.
5. Ibid.

with communal traumas, Greek tragedies being one example.[6] And recent studies have shown that dramatic enactment is often an effective way of transforming traumatic experiences in people suffering from post-traumatic stress disorder.[7] Today, our culture has the questionable tendency to process horror by creating varnished, somewhat detached re-enactments of events in the form of movies and television docudramas—disaster as entertainment.

Pickering's Incident pictures, like Fire Scene, are shot at the Fire Service College, but in facilities designed less for forensic analysis than for logistical and tactical training. Everything there is a rough approximation—sparse rooms built of concrete and metal contain simple forms such as a steel frame bed, filing cabinets, chairs, and human-shaped dummies made to withstand fire for future use. The only evidence of human presence is seen in finger and foot prints in the ash, traces of life that activate these charred, minimal spaces. Pickering takes inspiration from the grayness of the scene by pushing the contrast of her matte silver gelatin pictures to emphasize the expressive markings and their relationship to drawing. The lines appear to have occurred directly on the surface of the photograph, highlighting the materiality of the images themselves, and heightening the slippage between positive and negative, illusion and reality. The markings are a process of subtraction, an appropriate metaphor for an image of aftermath where color and life have been siphoned out of the scene.

Inspired by Cormac McCarthy's The Road, Pickering titled a 2009 exhibition of her Explosion and Incident series Holding Fire. In the novel, about a father and son journeying through a post-apocalyptic landscape that is completely bleak and gray, fire becomes a symbol of hope, and possessing it helps the characters feel both physically and psychologically comforted. For Pickering, these scenes were resonant, as they describe how we cling to the idea of control even in the most extreme circumstances. The idea of carrying fire, an ephemeral phenomenon, also has a parallel to photography. The idea of stopping time, and preserving things and people by possessing their image, has endowed photography with perceived powers—the ability to bridge distances, provide comfort, and even counter death.

The terror of security resides in the mental space between acceptance and denial, preparedness and ignorance, control and disorder. The ambiguity of fear, and the unsettling revelation that preparedness can be futile is addressed in The Road in a scene in which the man and the boy meet an old man who claims to have known that a disaster was imminent in the world:

I knew this was coming.
Yeah. This or something like it. I always believed in it.
Did you try to get ready for it?
No. What would you do?
I dont know.
People were always getting ready for tomorrow. I didnt believe in that. Tomorrow wasnt getting ready for them. It didnt even know they were there.[8]

KAREN IRVINE

Curator

Museum of Contemporary Photography at Columbia College Chicago

6. Bessel A. van der Kolk, M.D., "Posttraumatic Therapy in the Age of Neuroscience," *Psychoanalytic Dialogues* 12 (2002): 388.
7. Ibid.
8. Cormac McCarthy, *The Road* (New York: Vintage International, 2006), p. 168.

9

PUBLIC ORDER

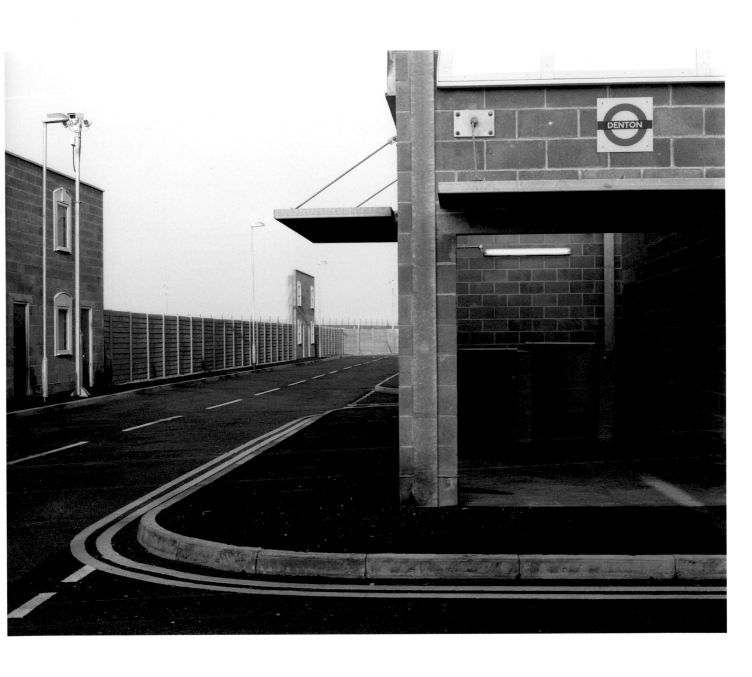

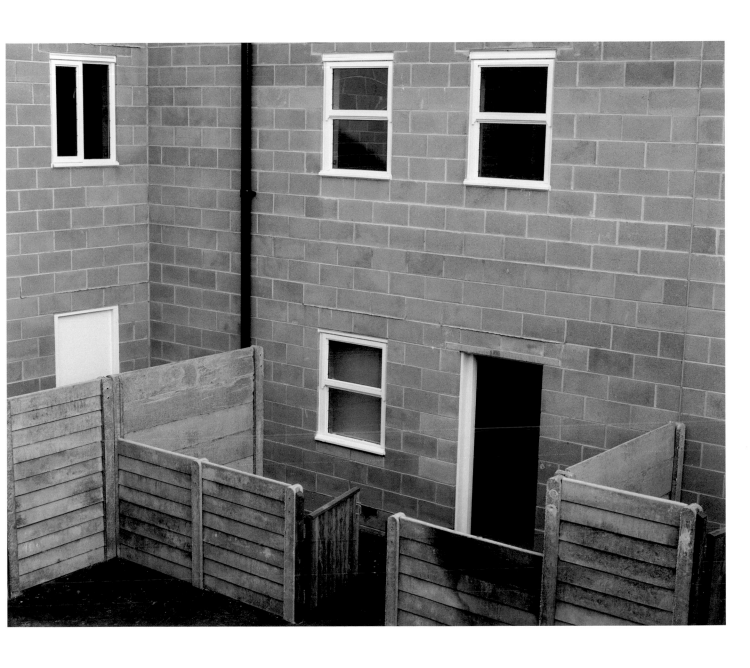

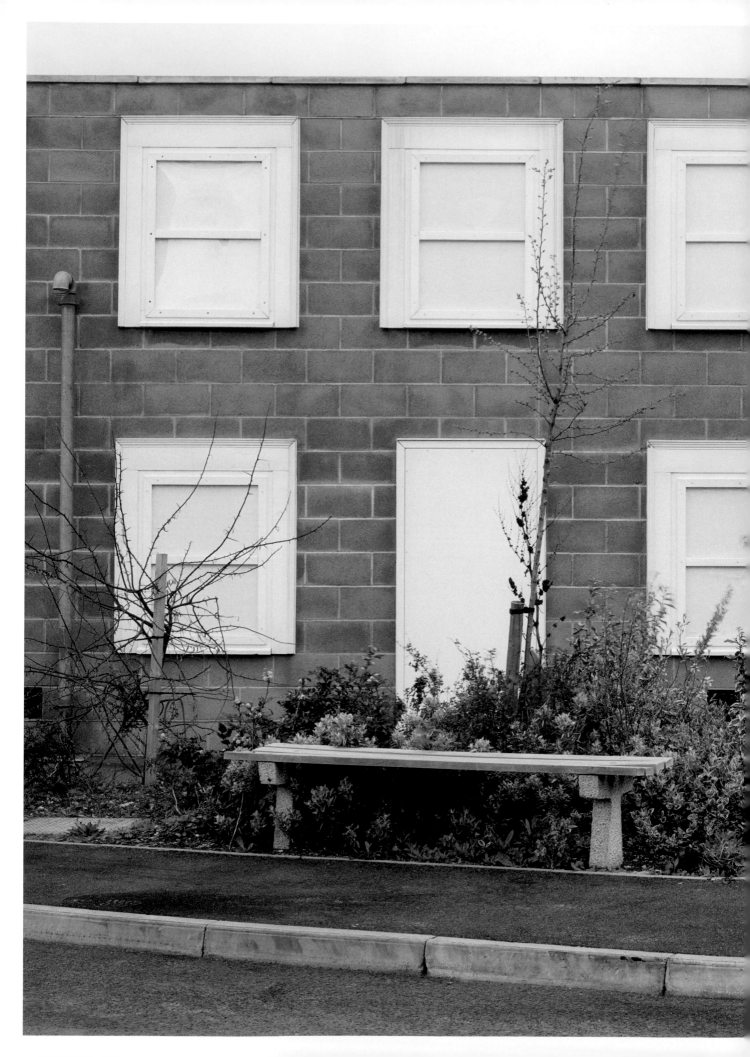

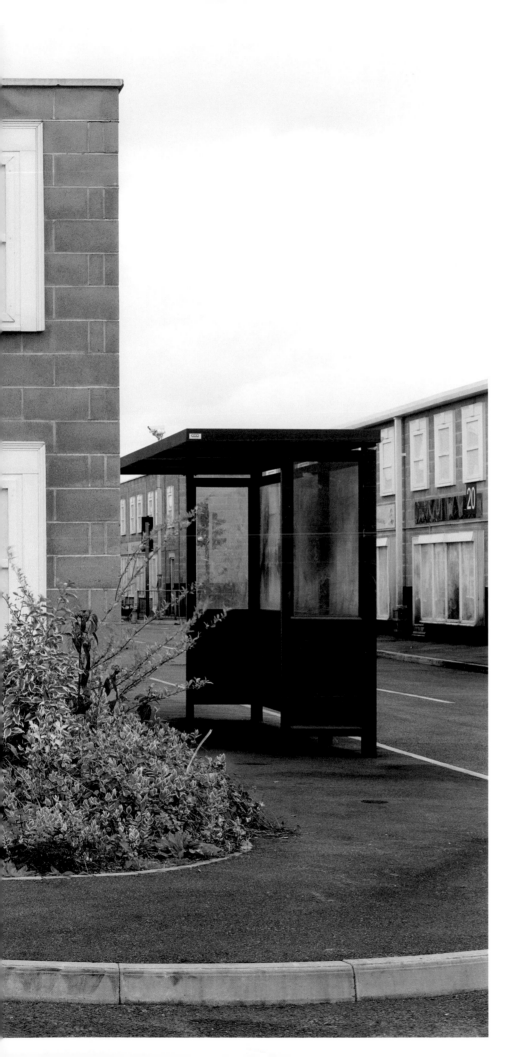

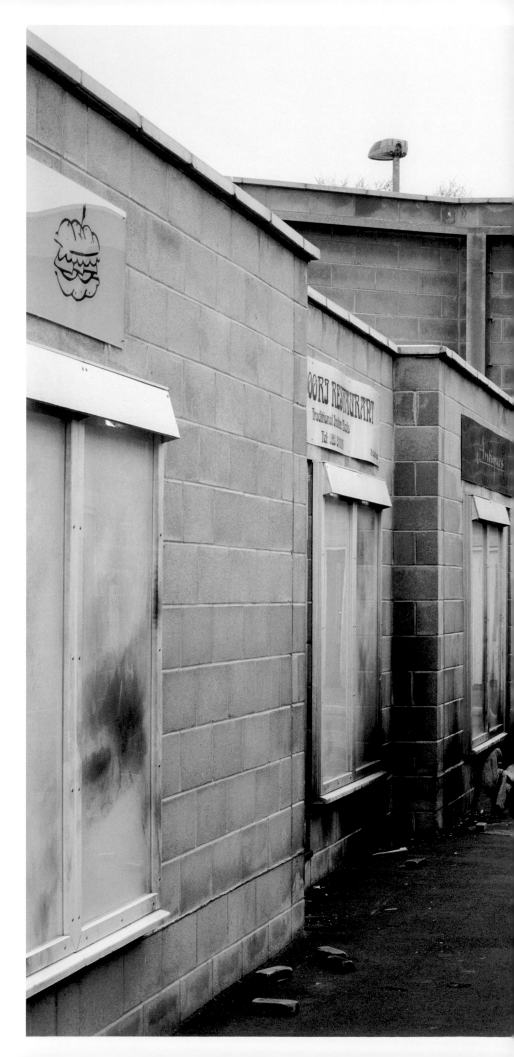

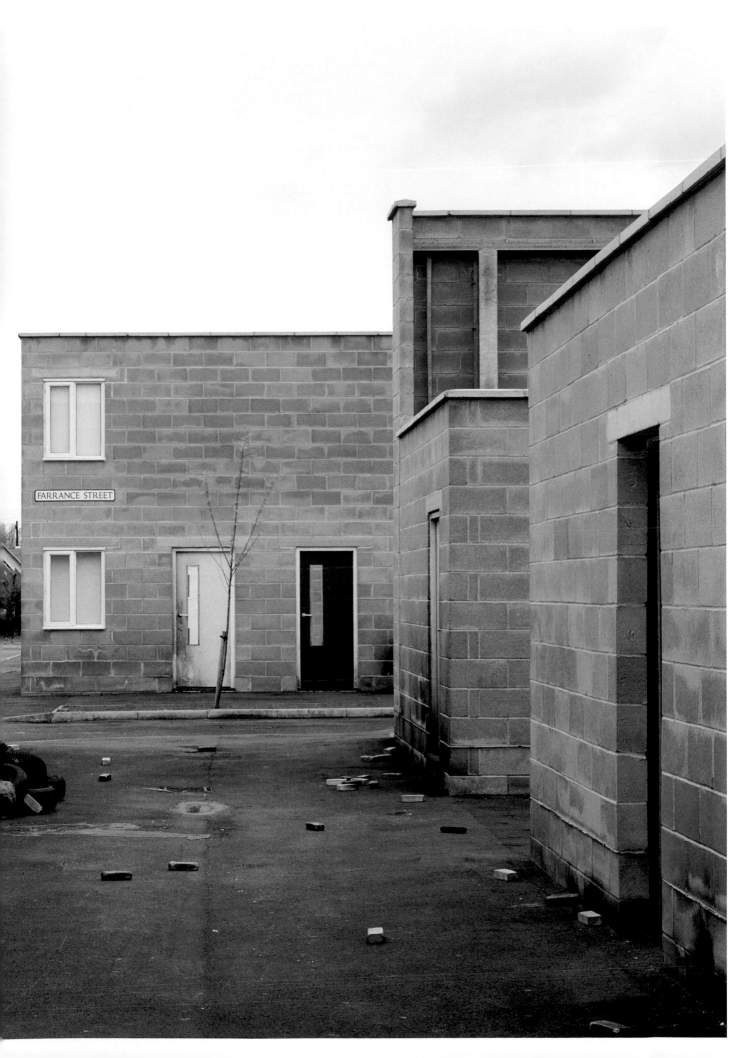

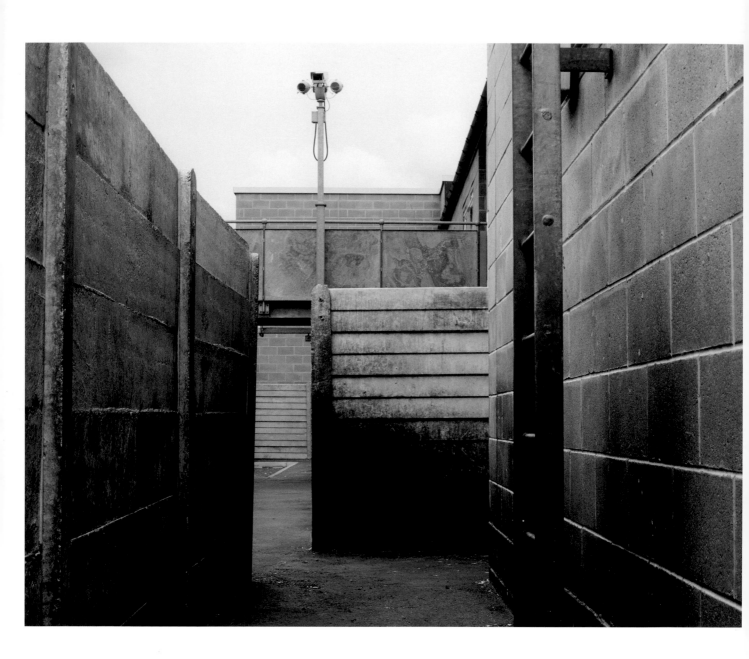

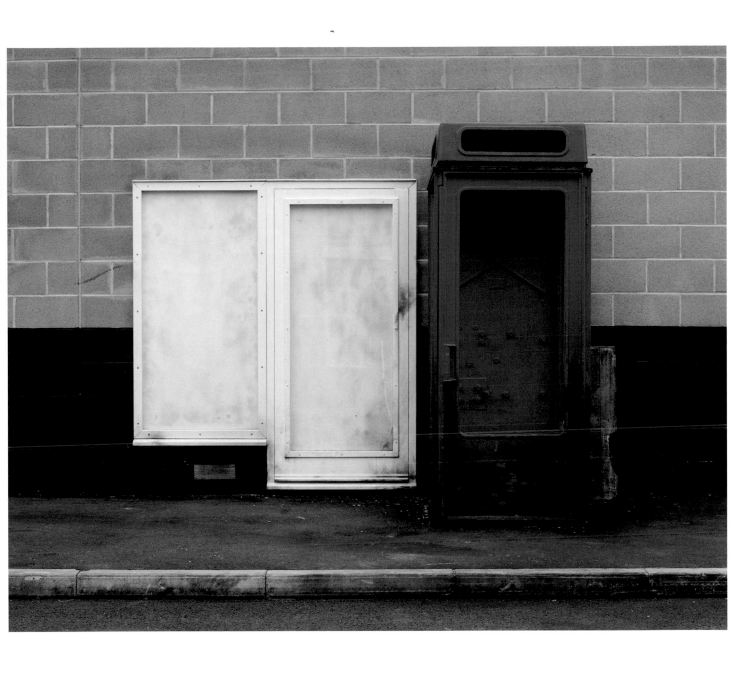

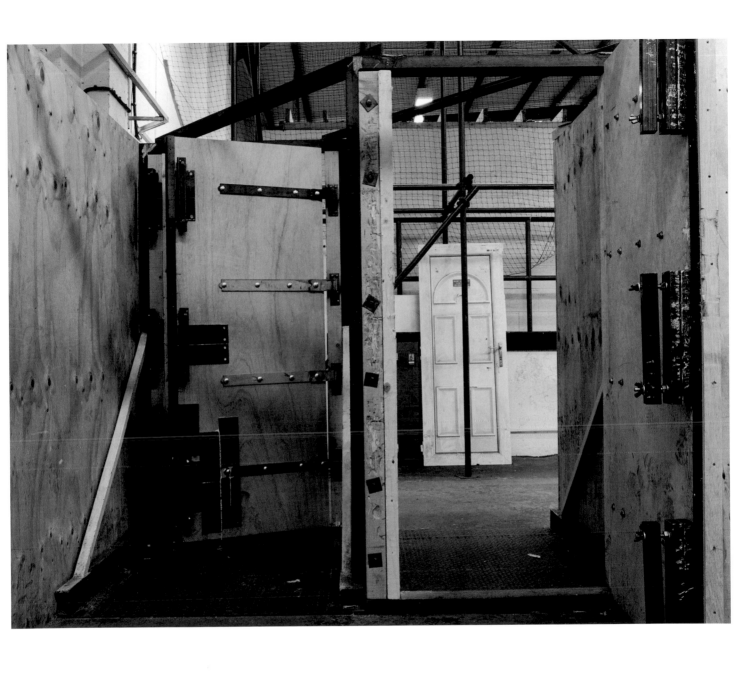

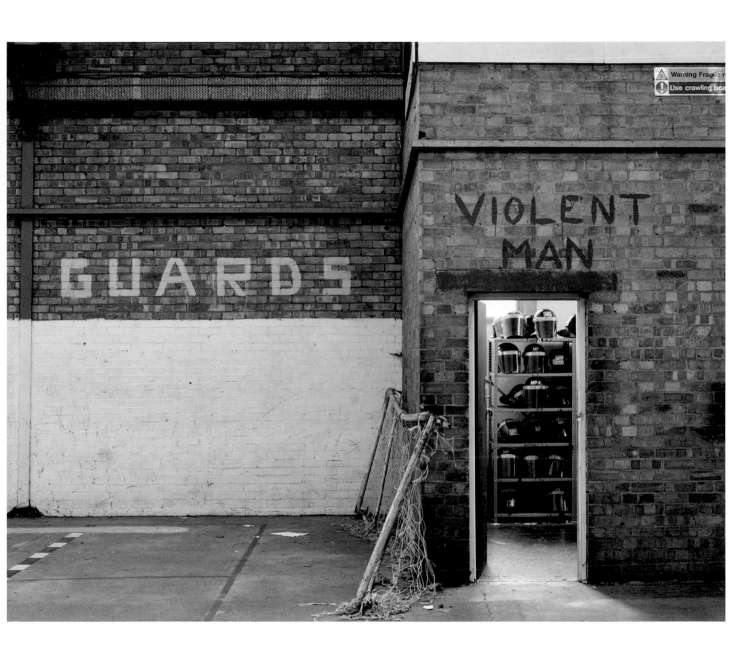

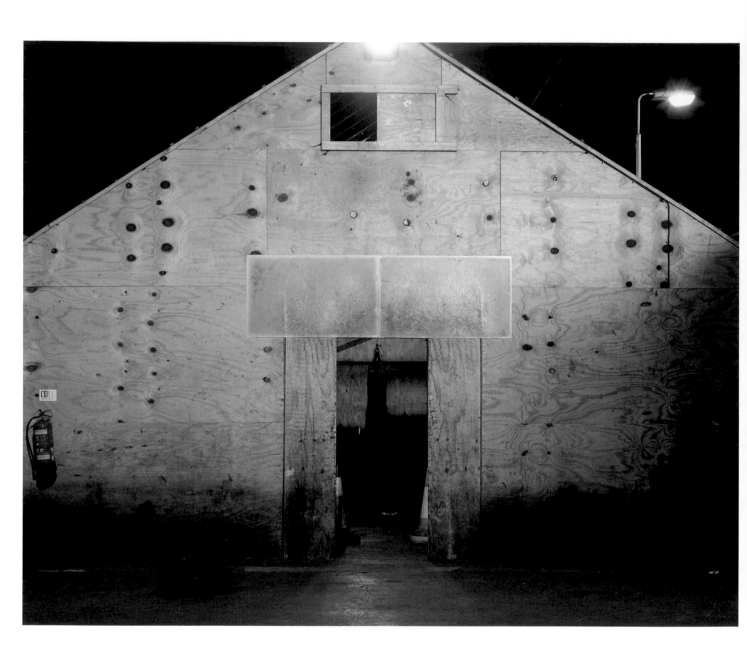

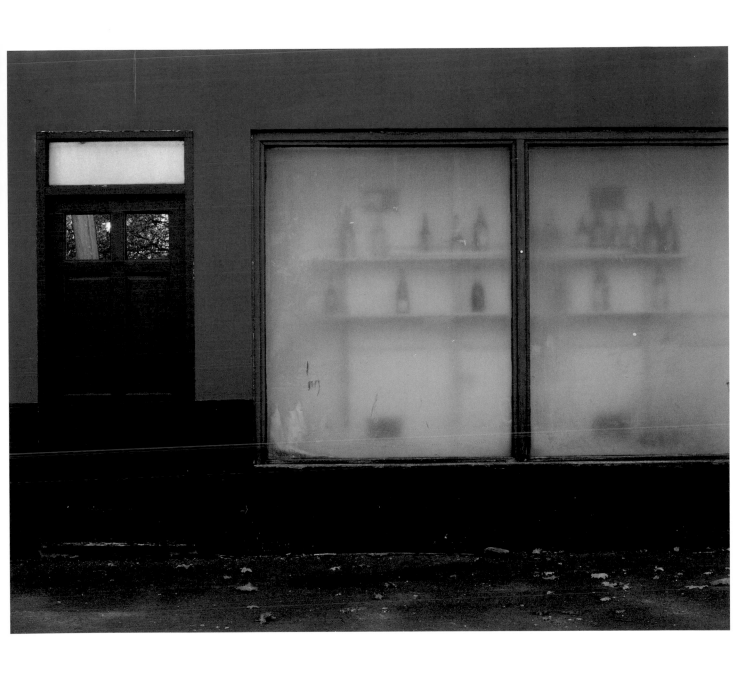

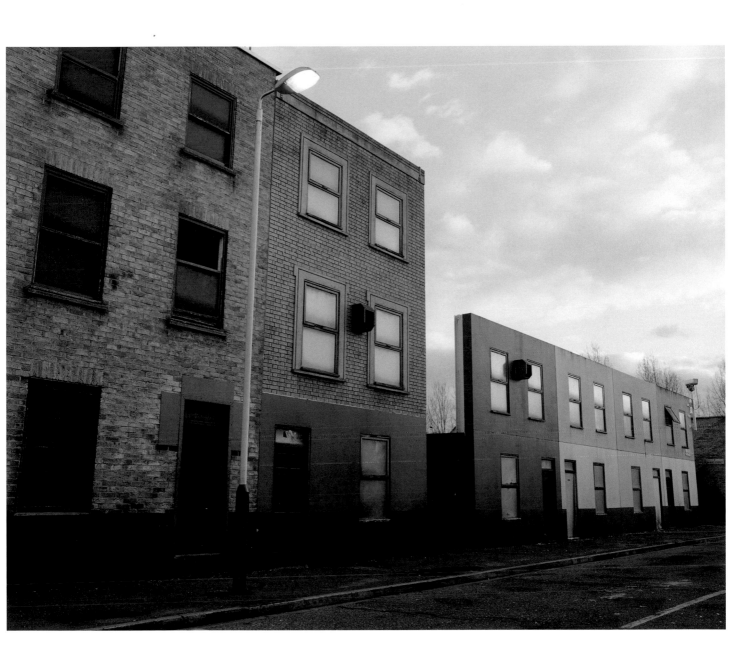

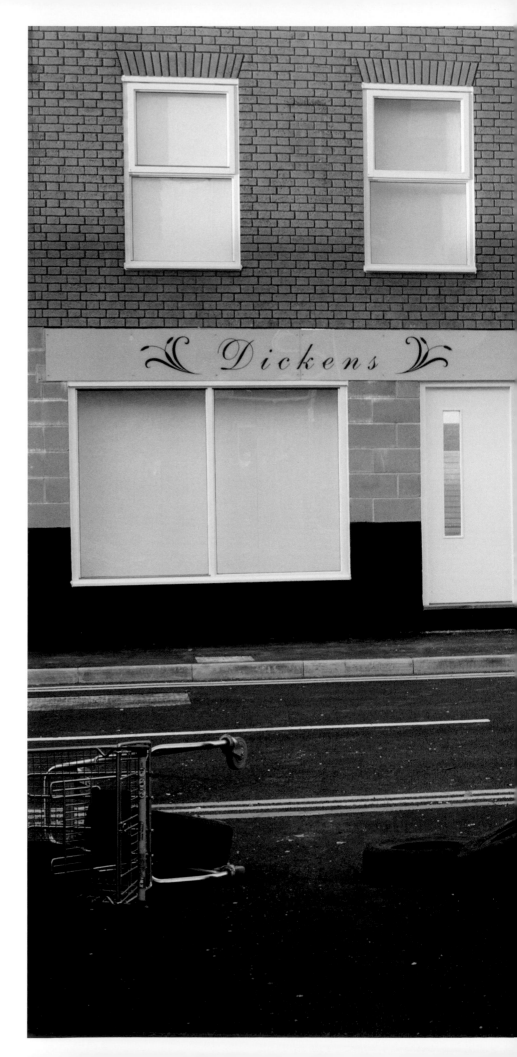

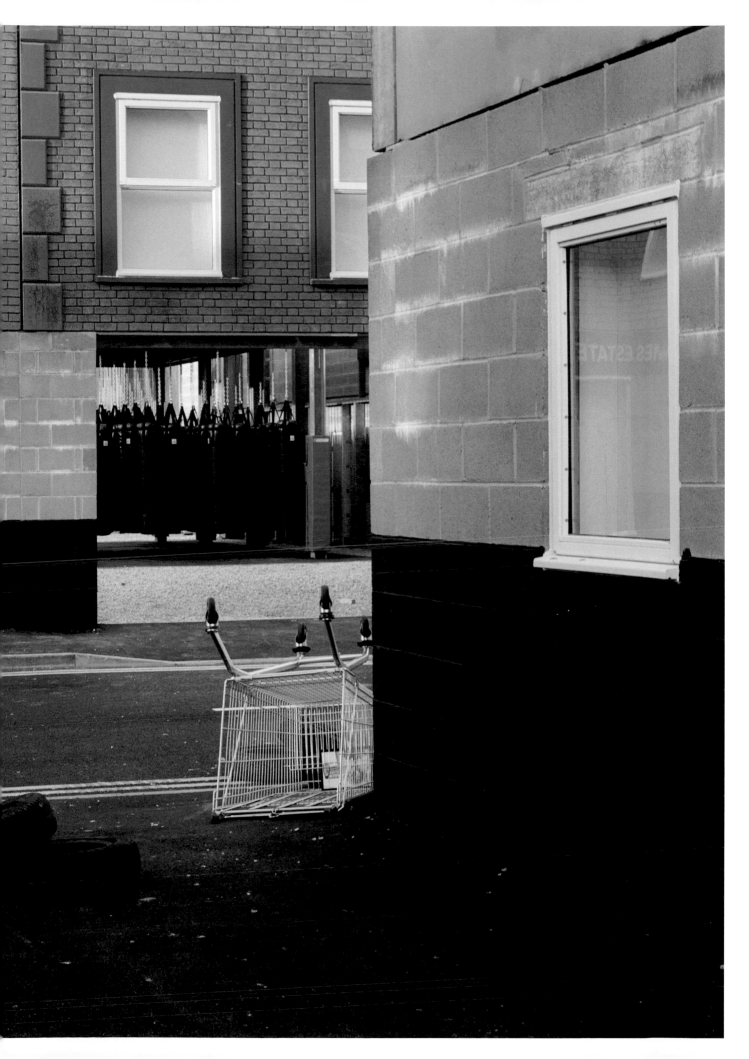

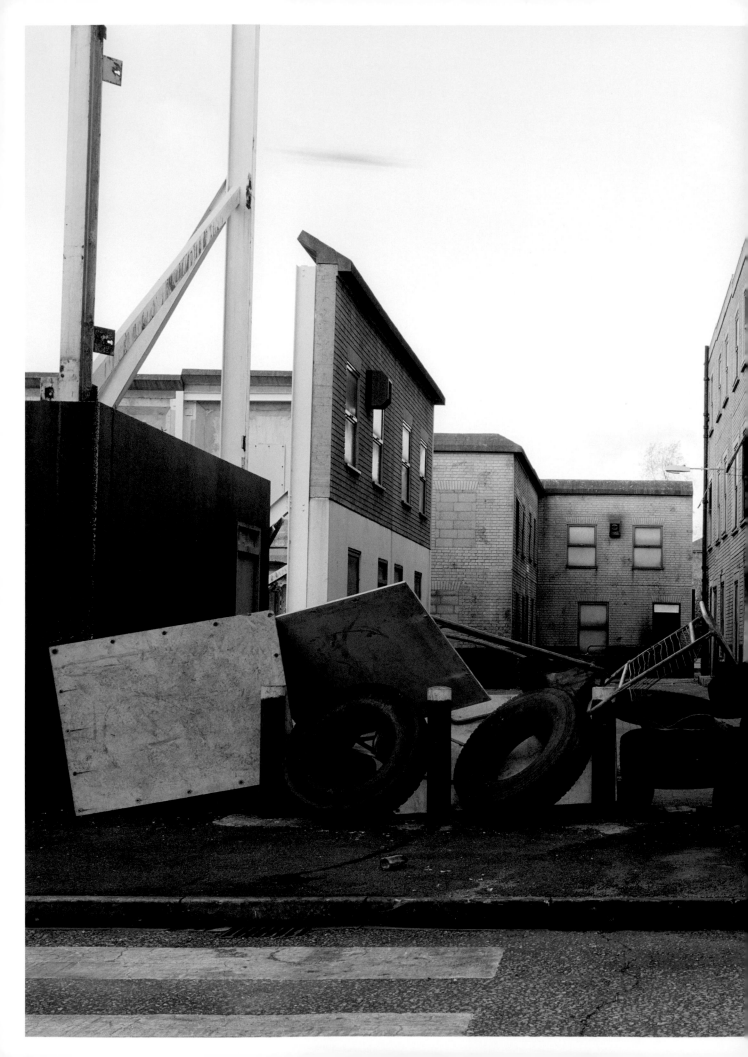

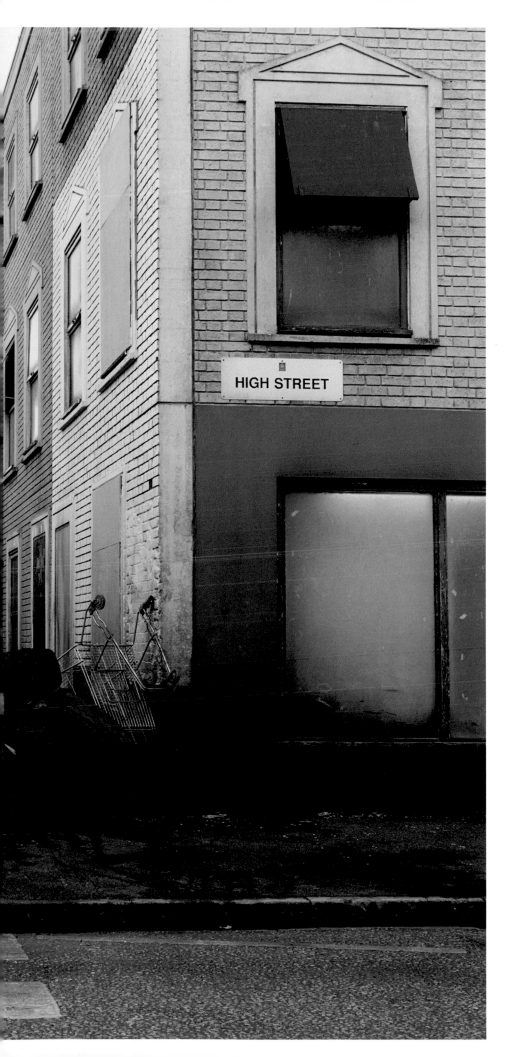

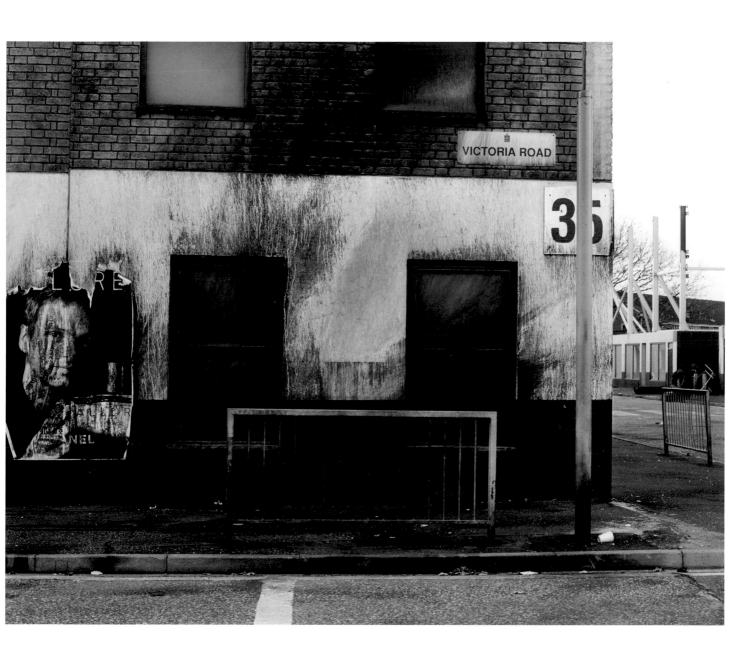

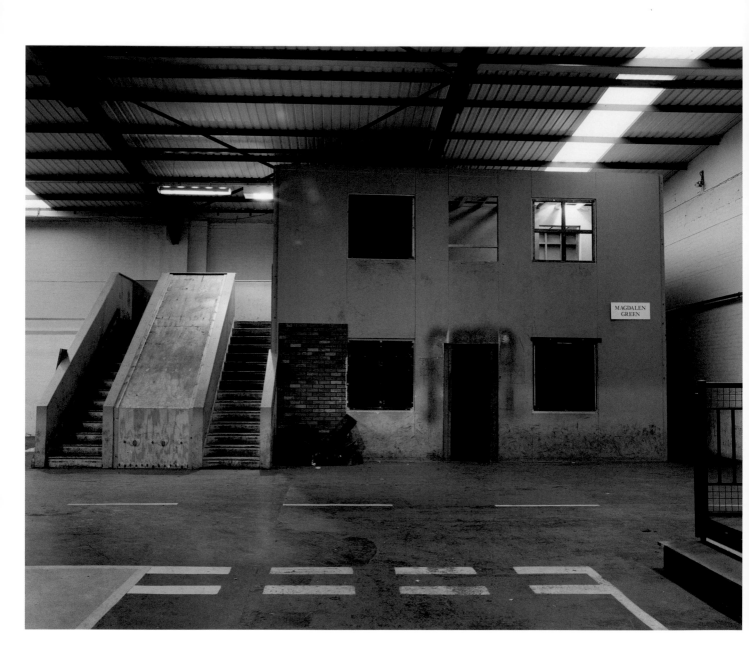

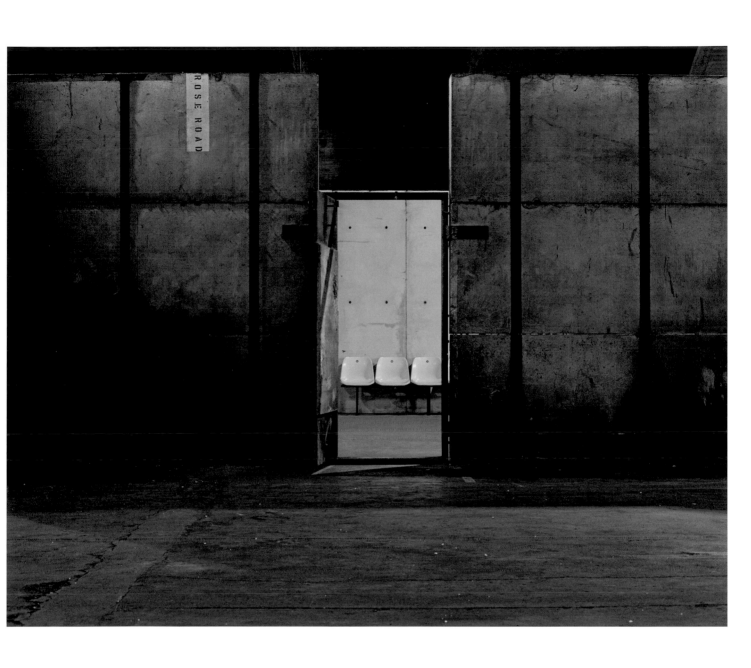

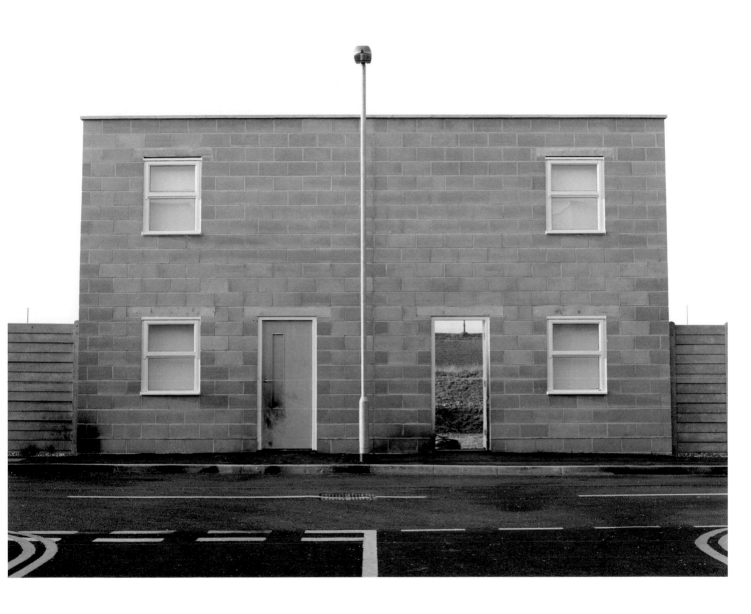

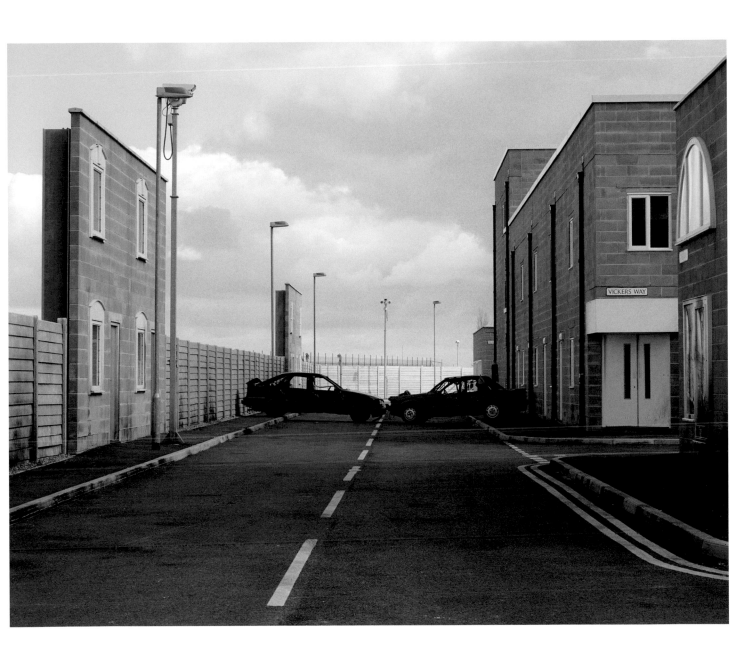

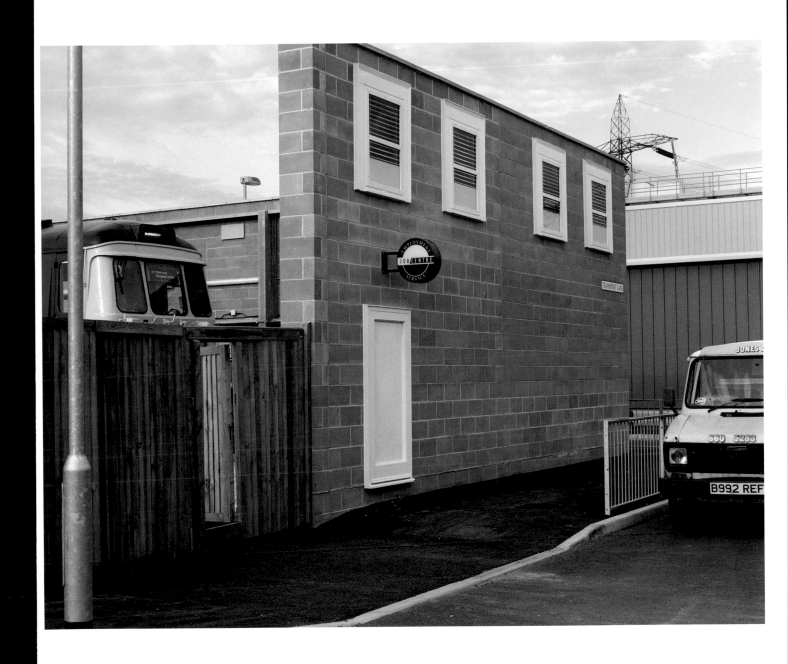

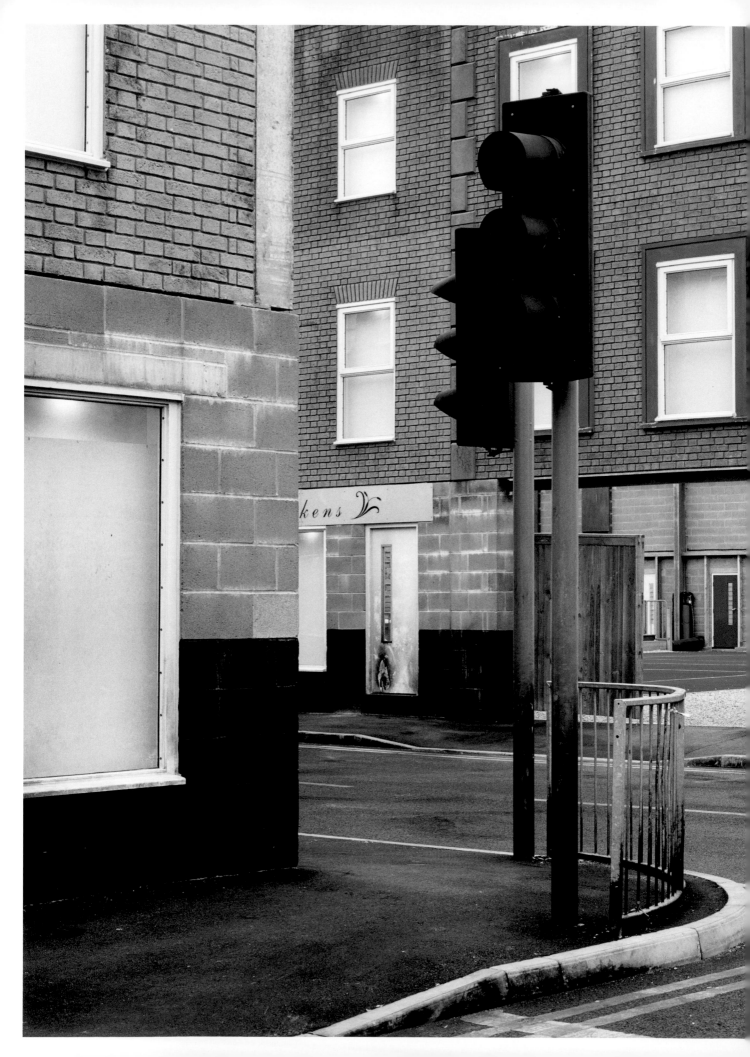

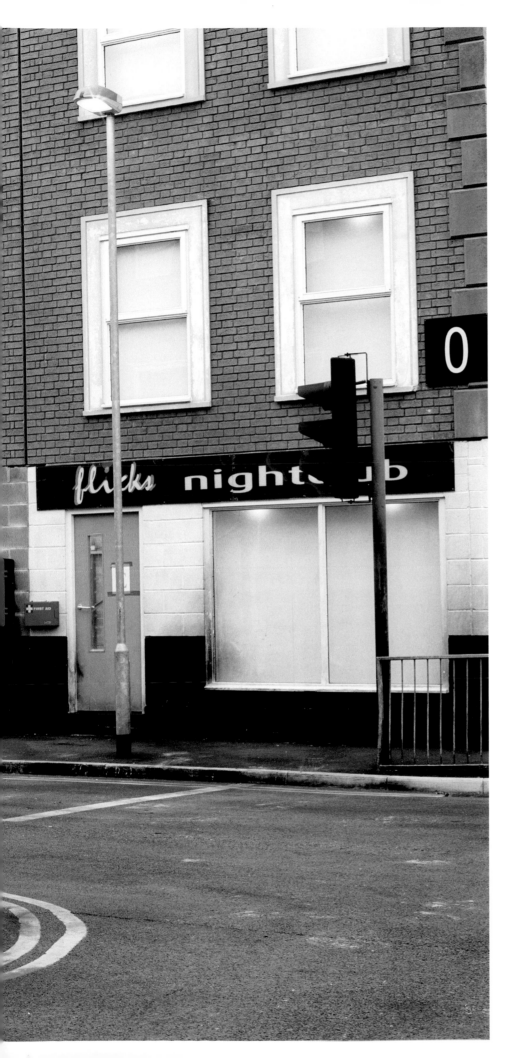

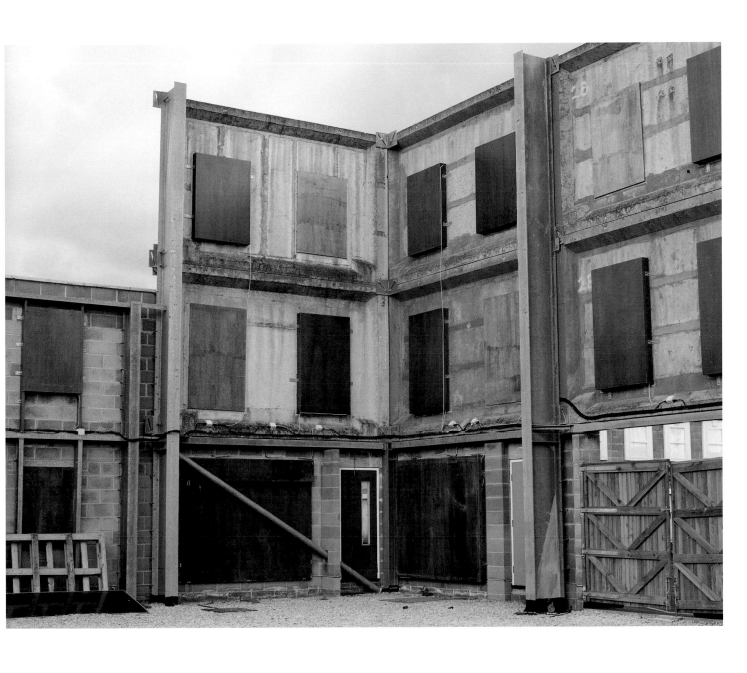

EXPLOSION

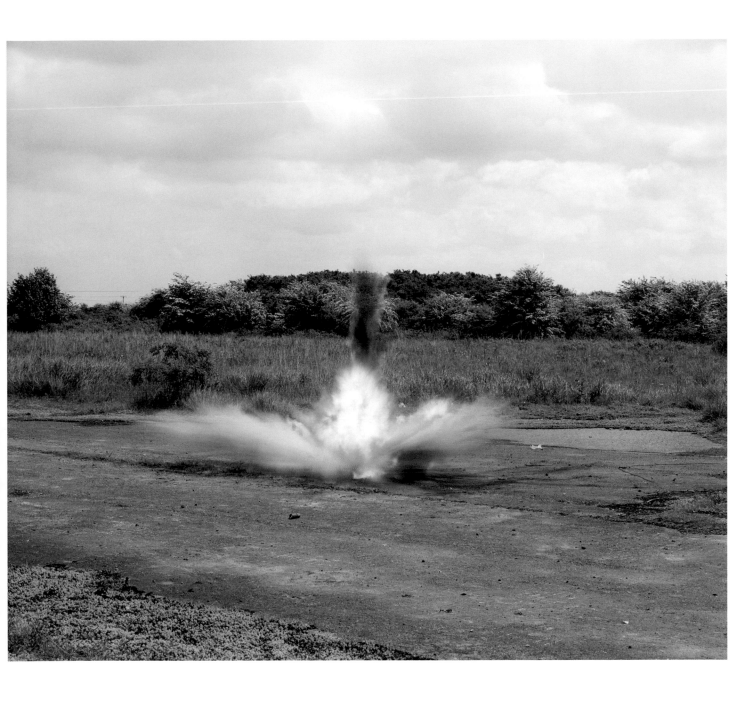

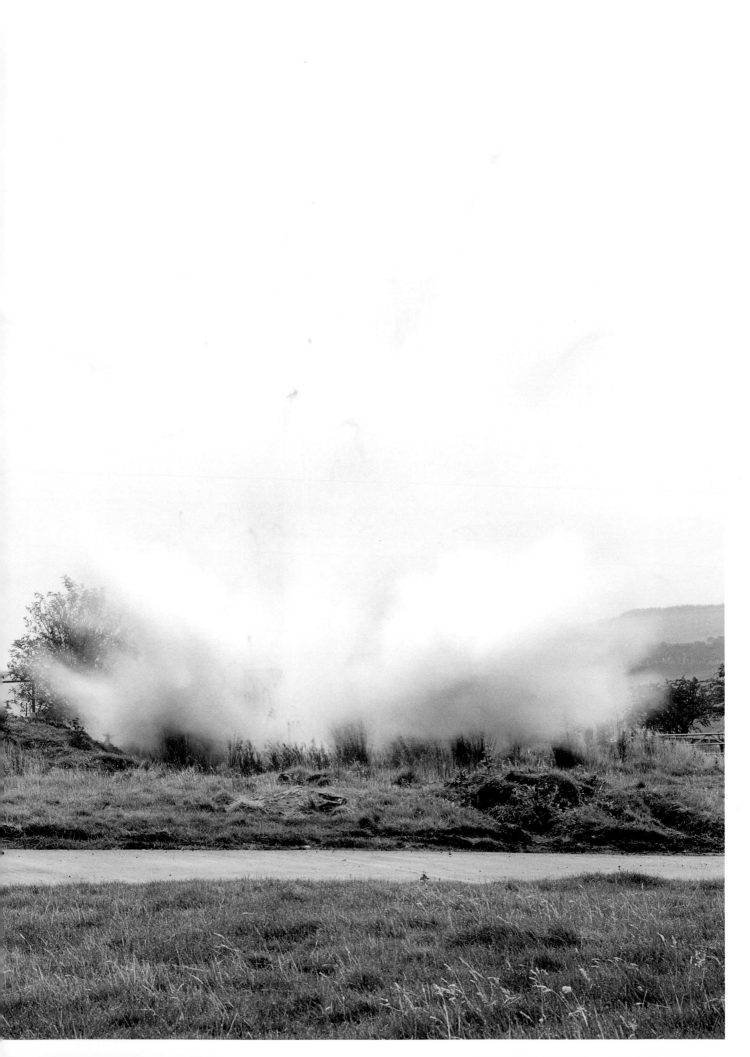

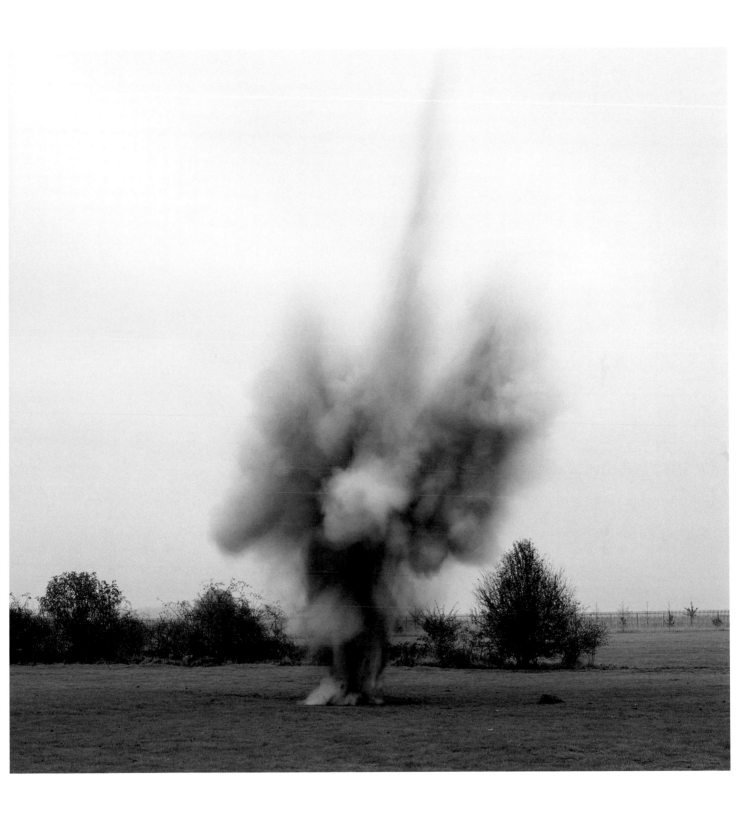

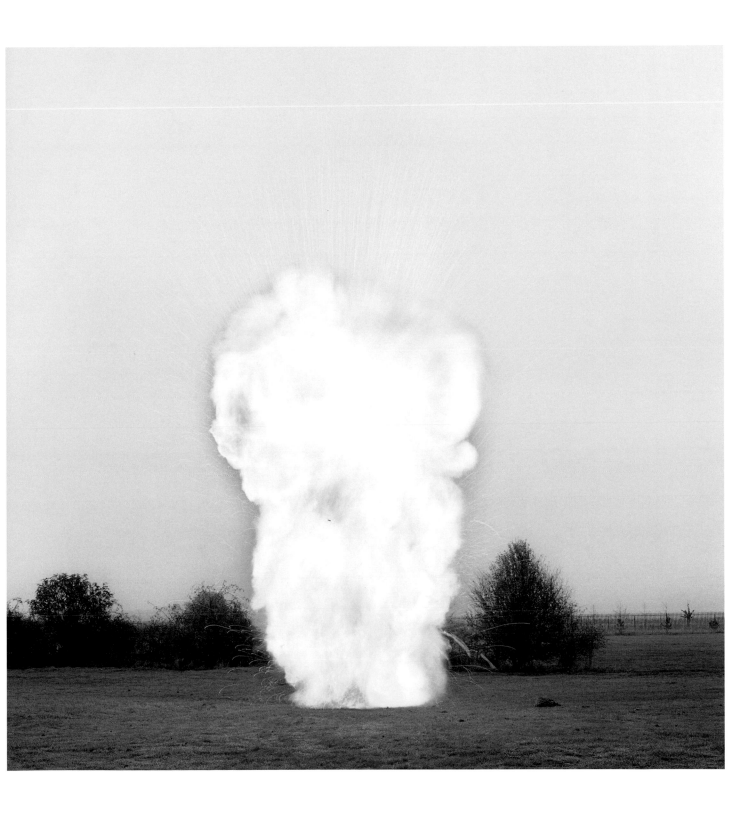

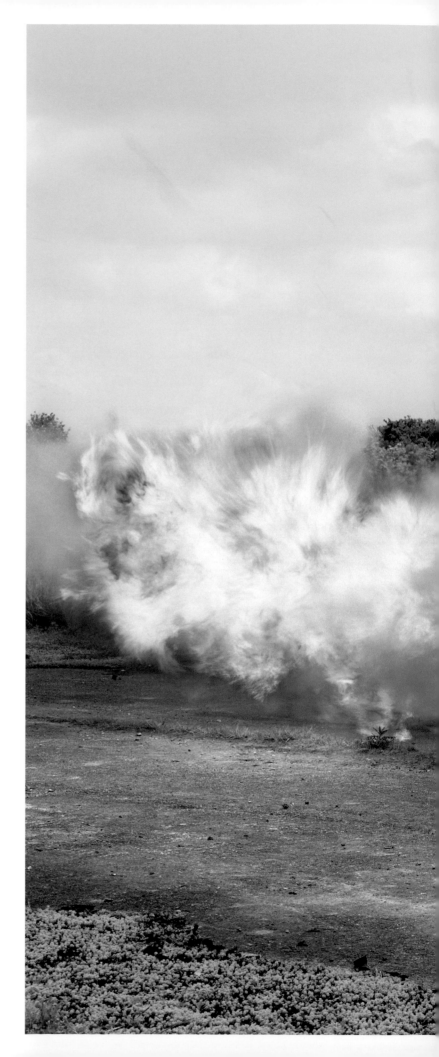

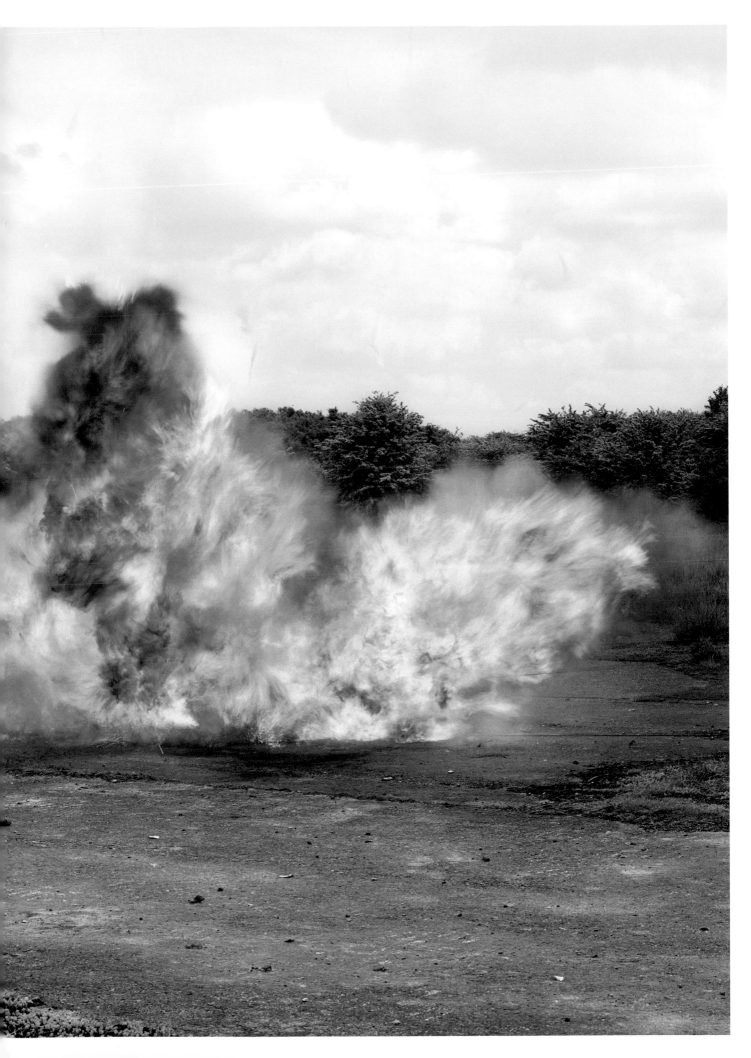

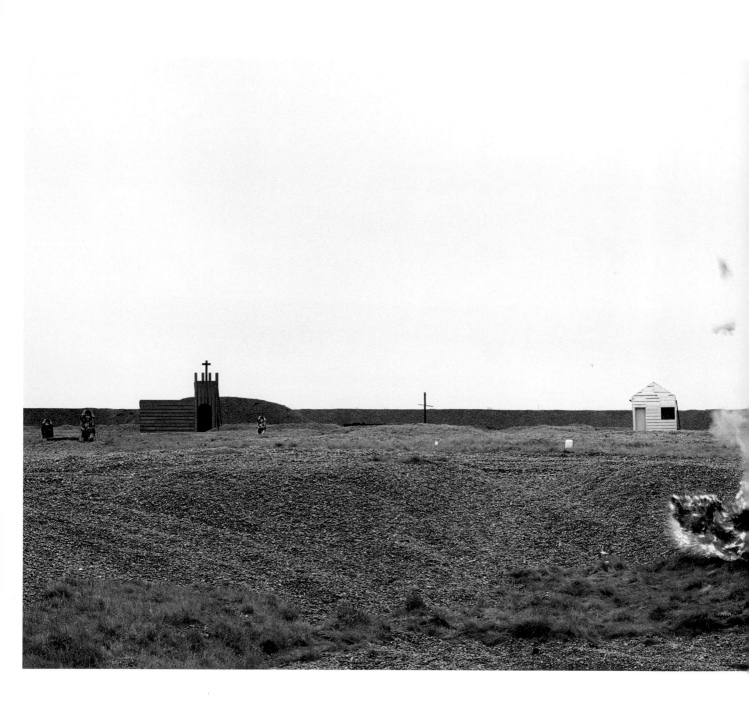

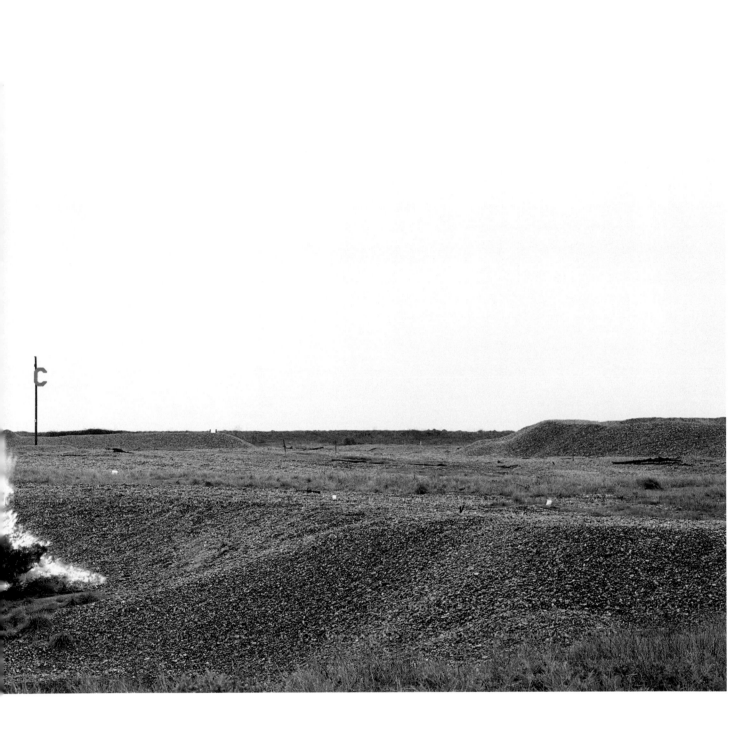

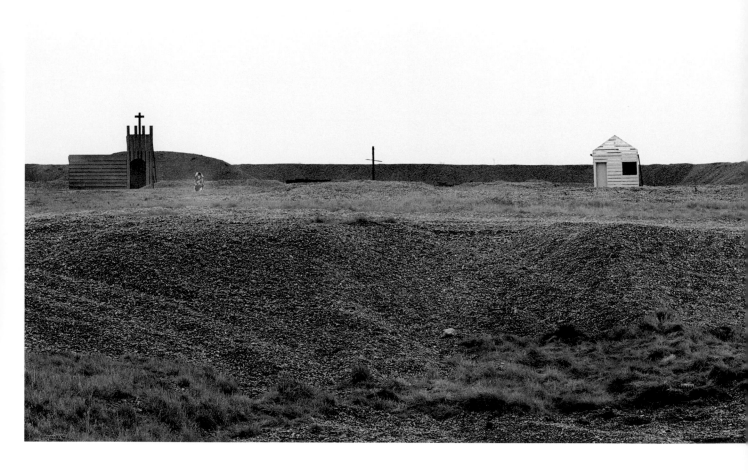

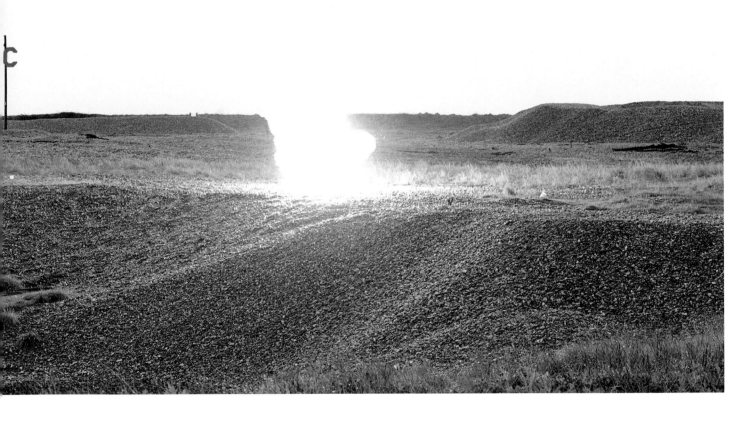

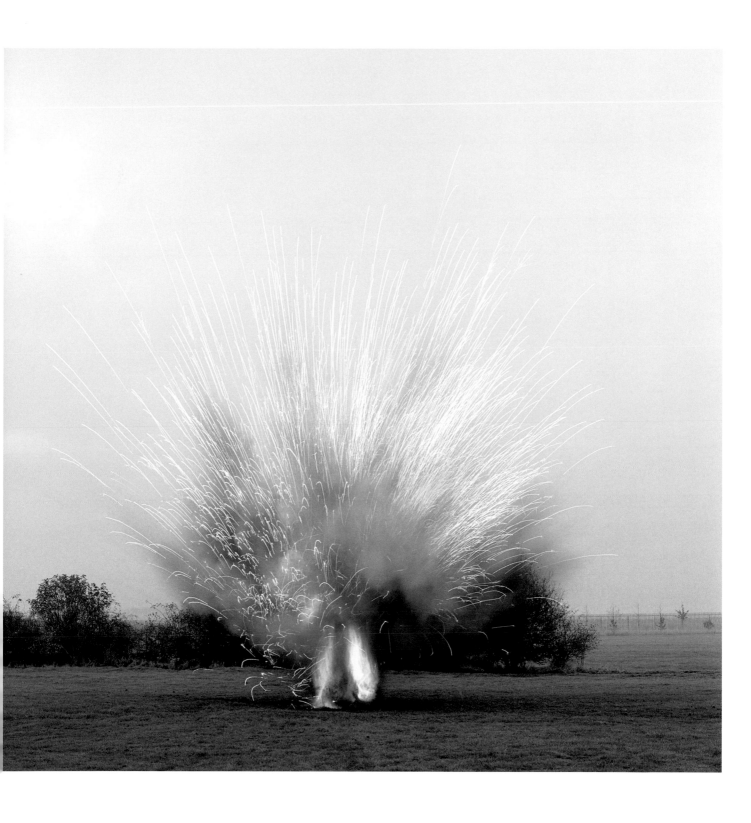

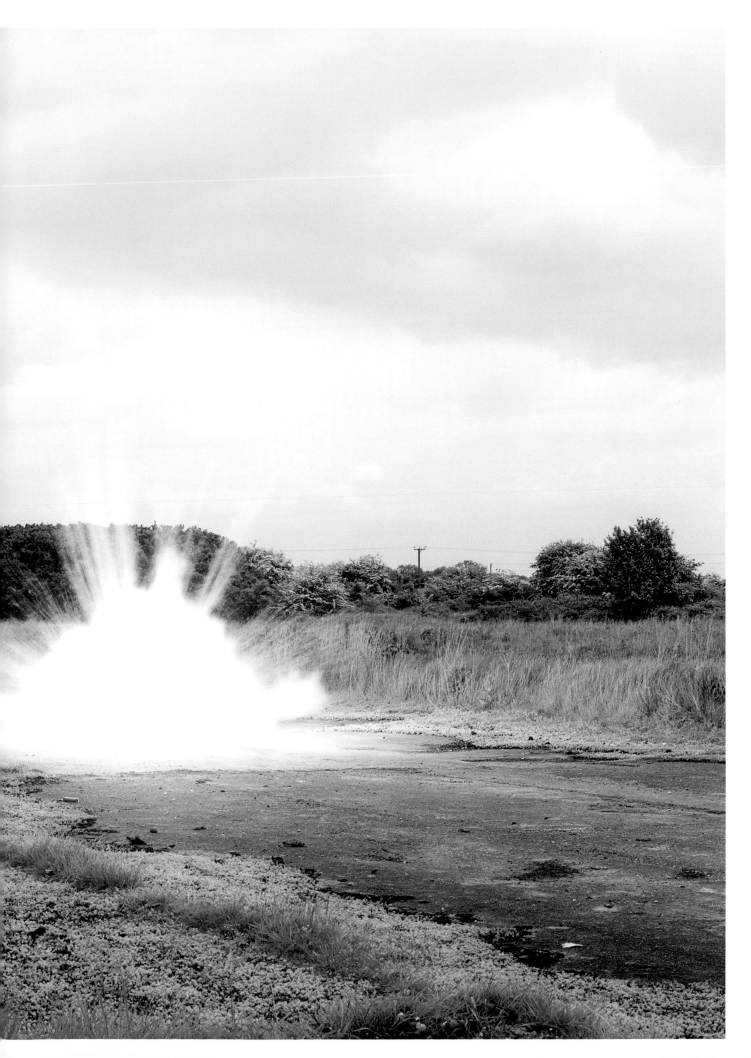

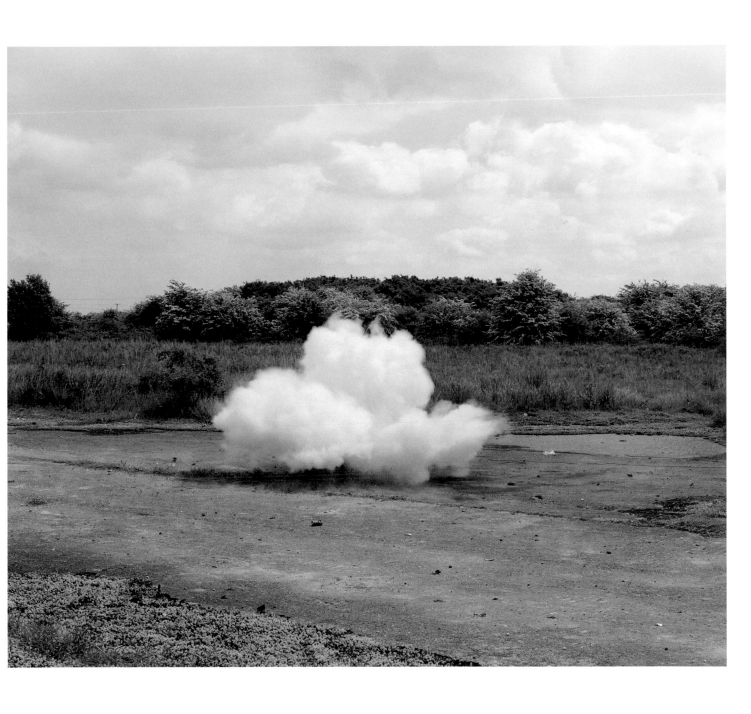

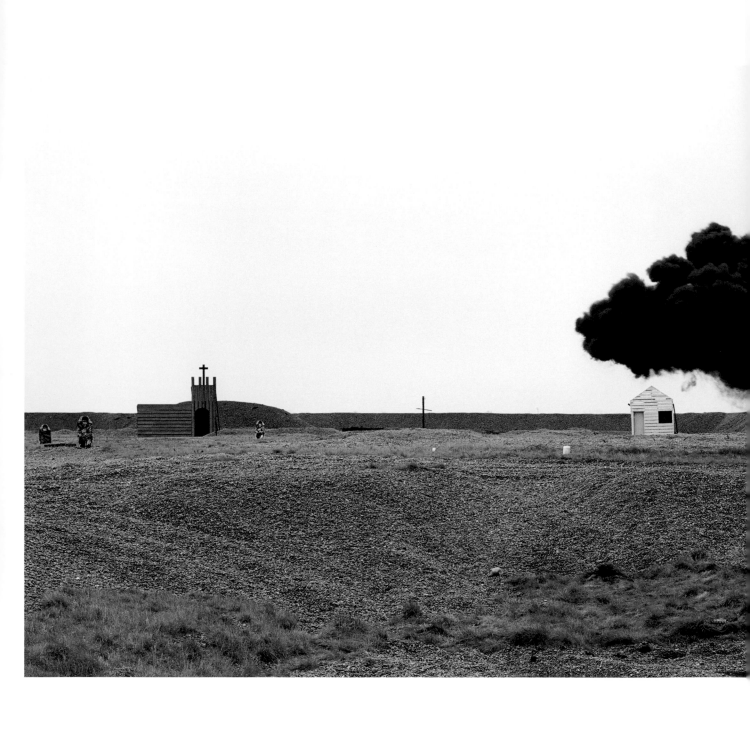

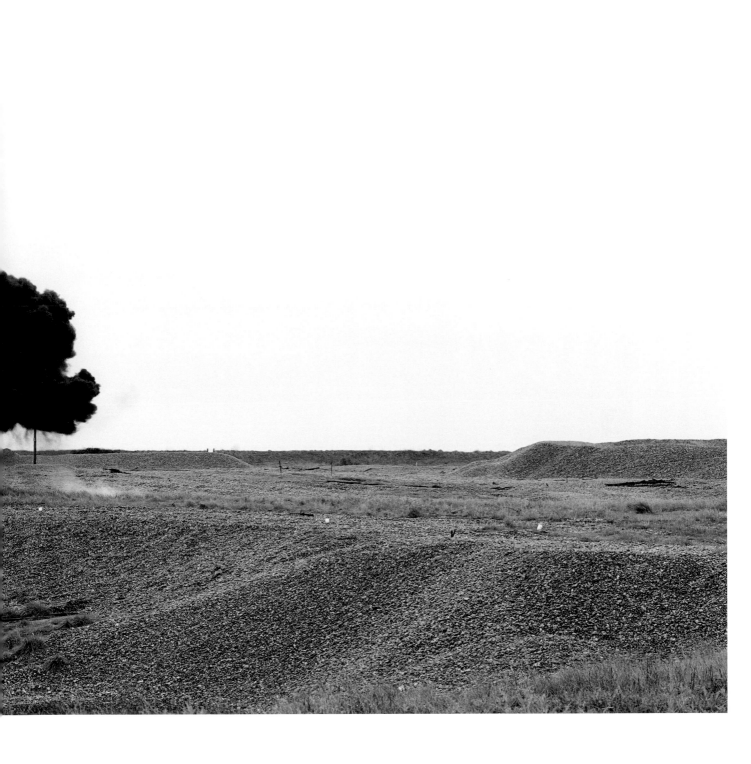

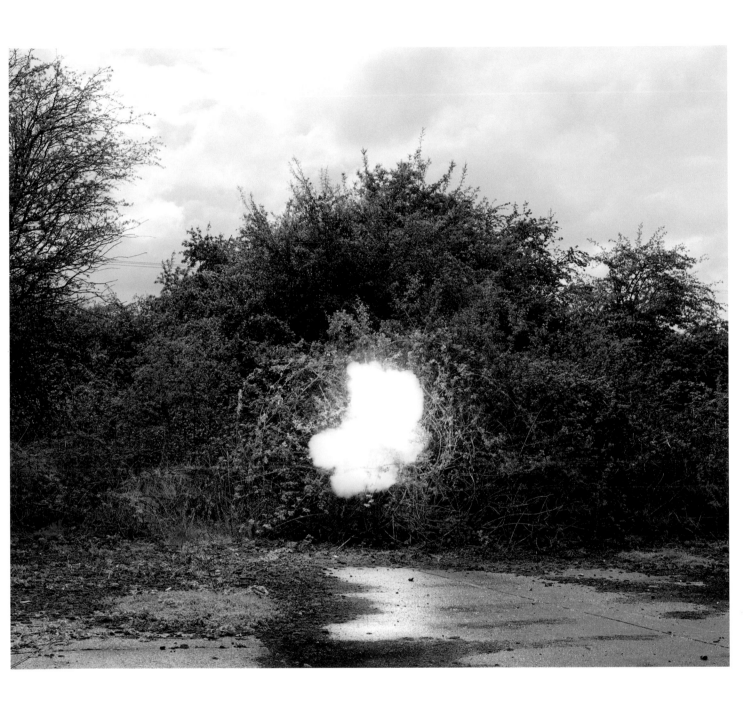

FIRE SCENE

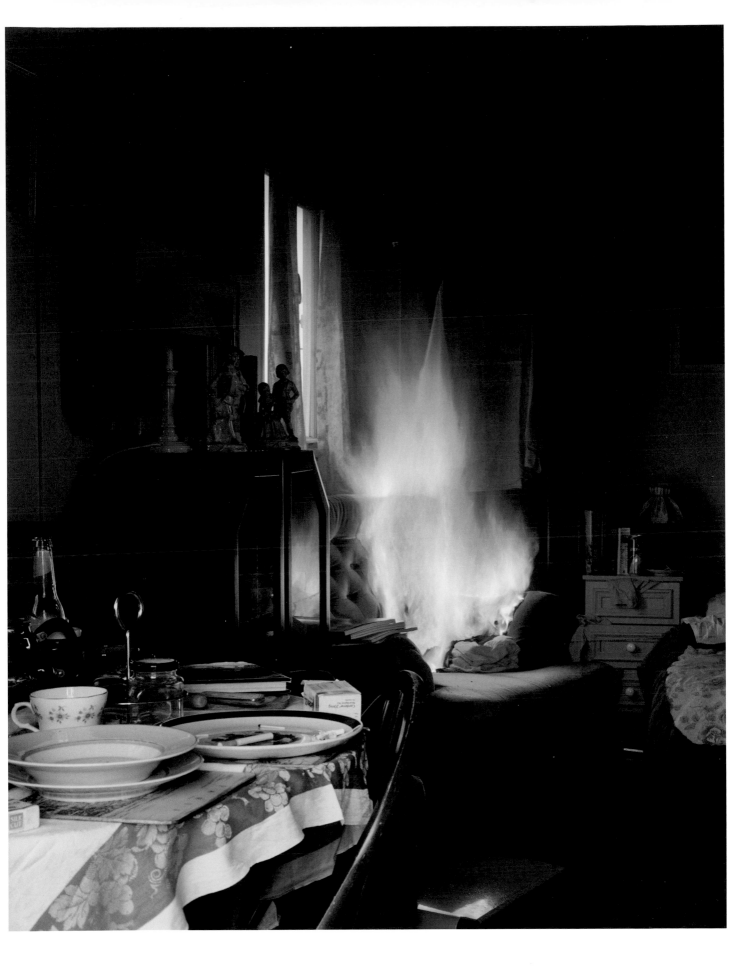

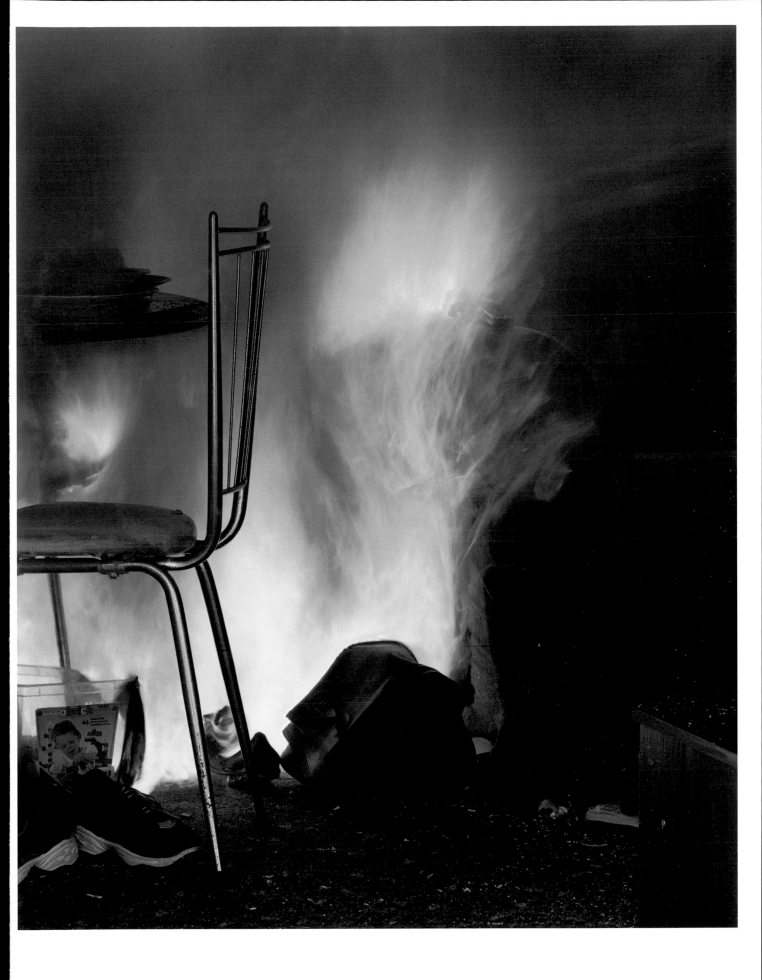

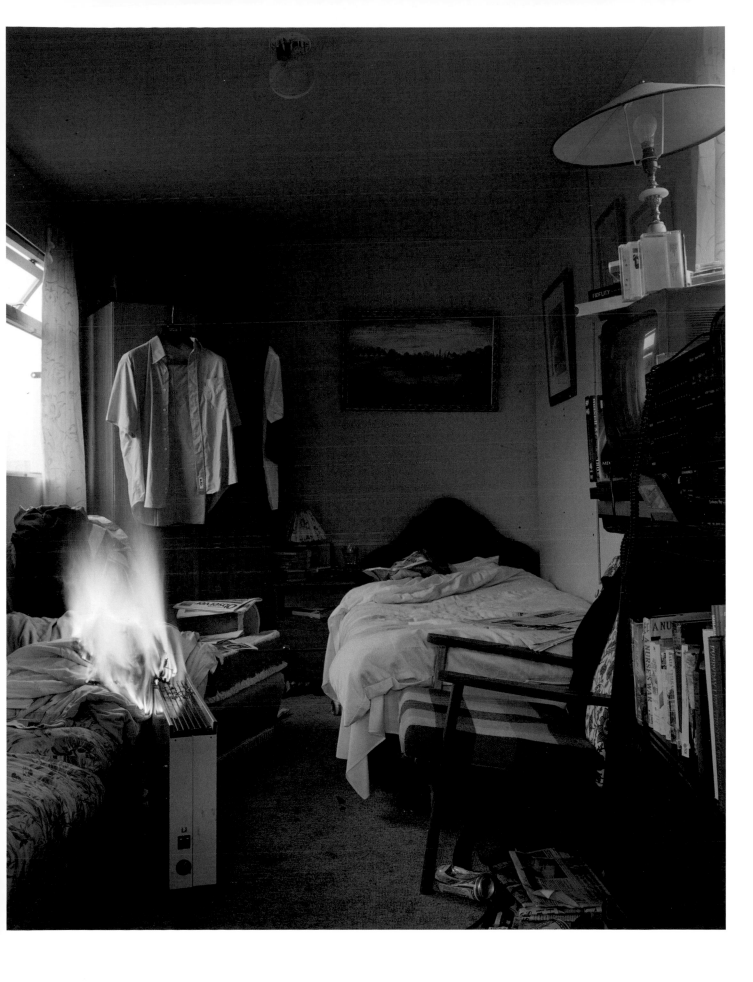

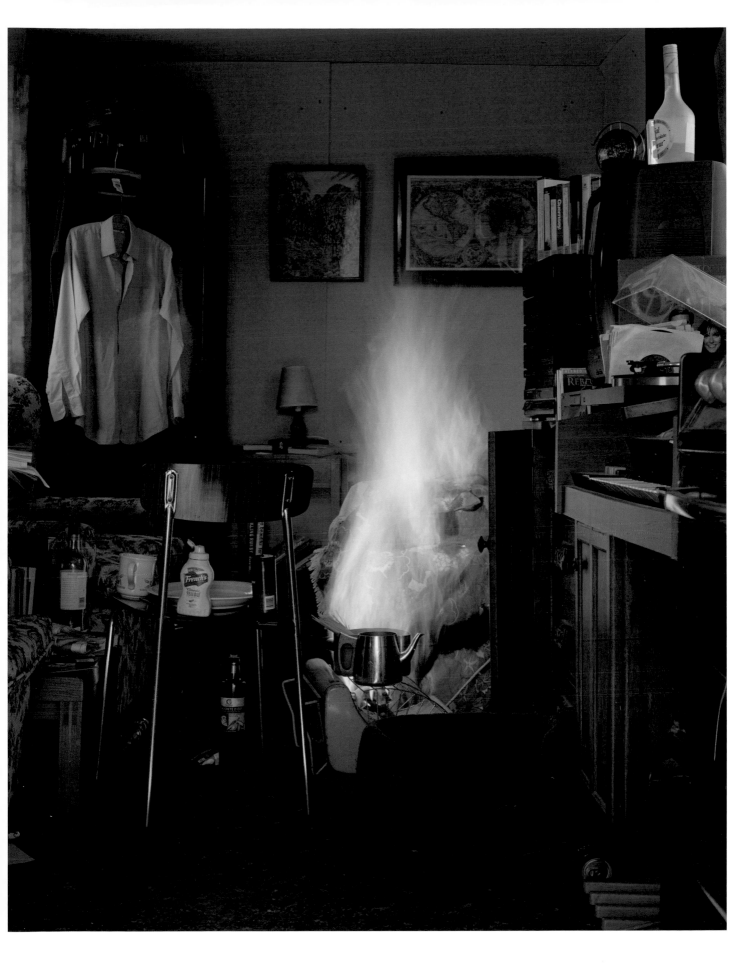

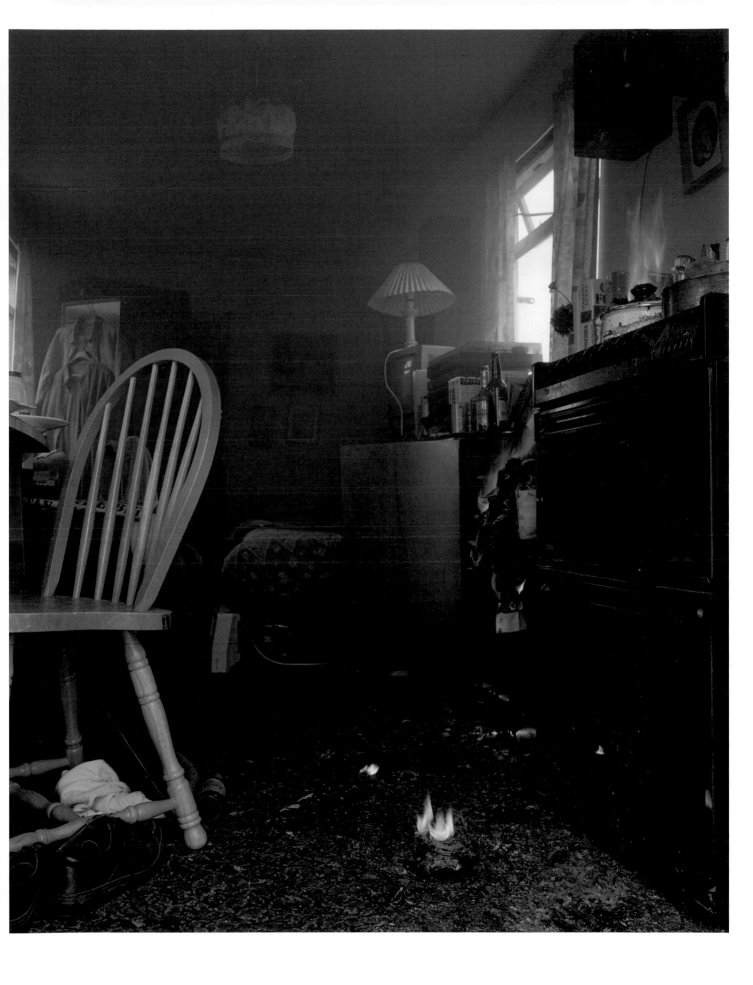

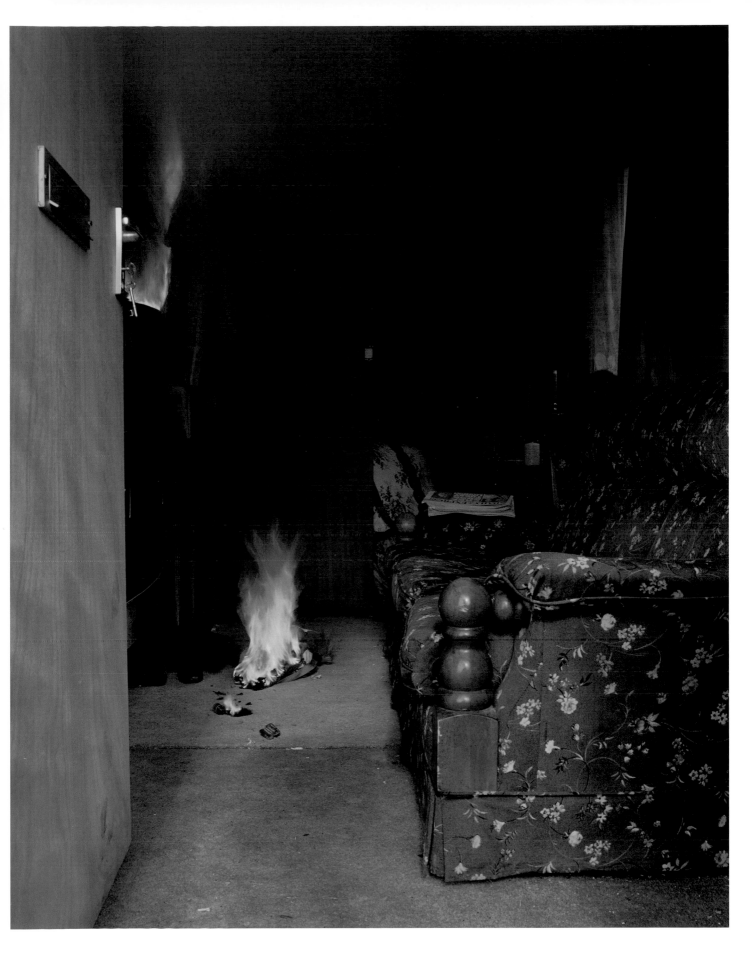

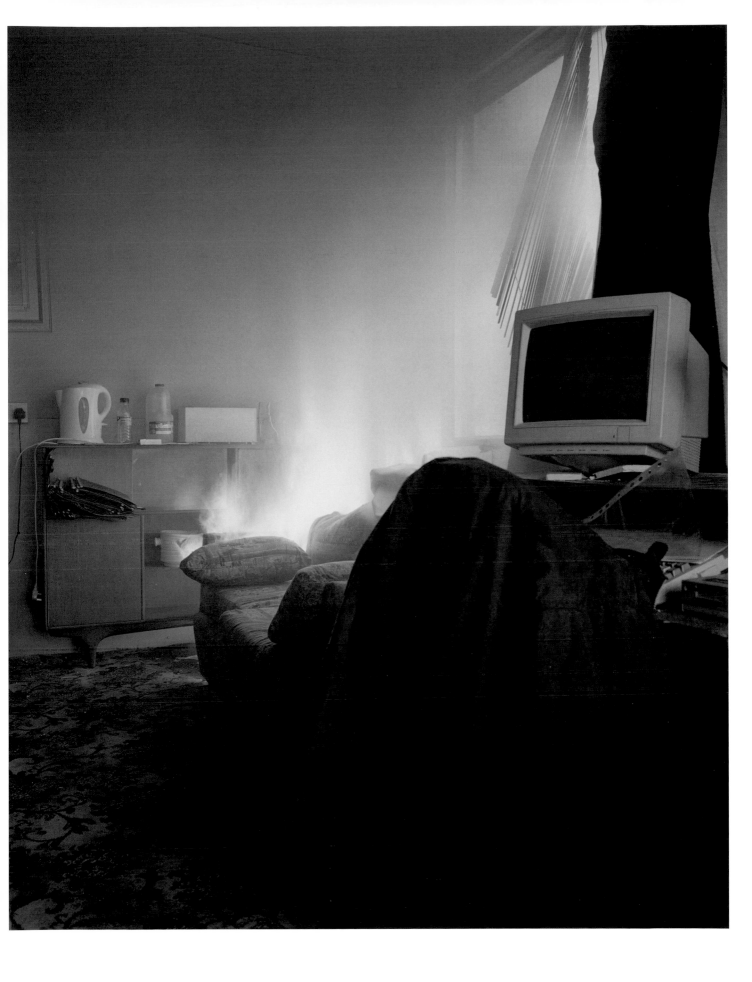

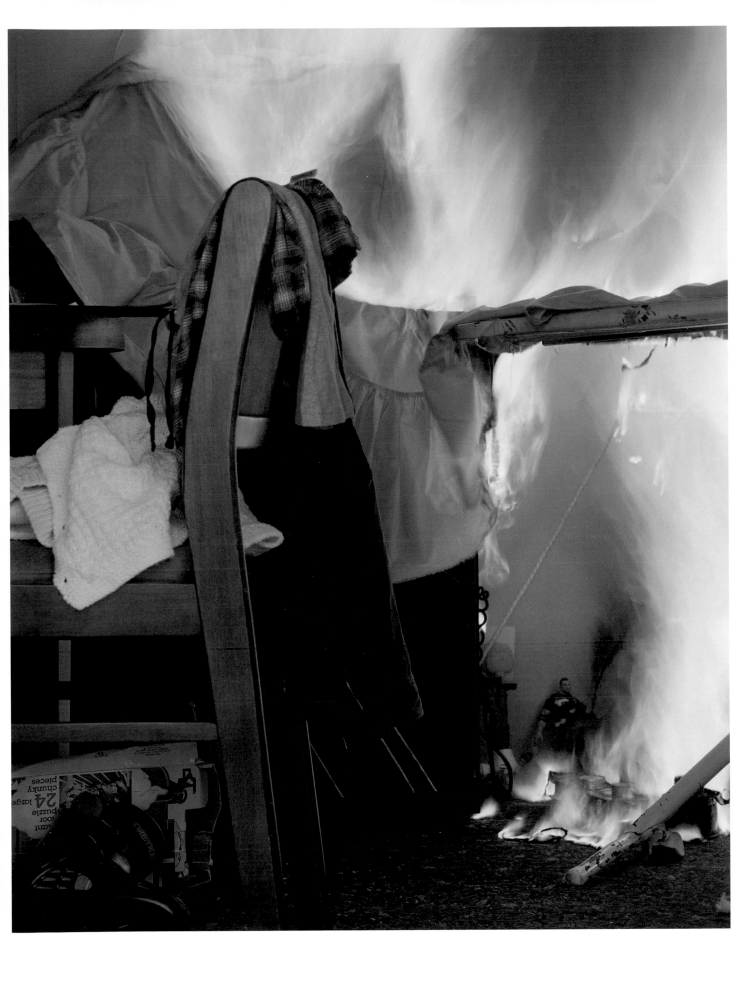

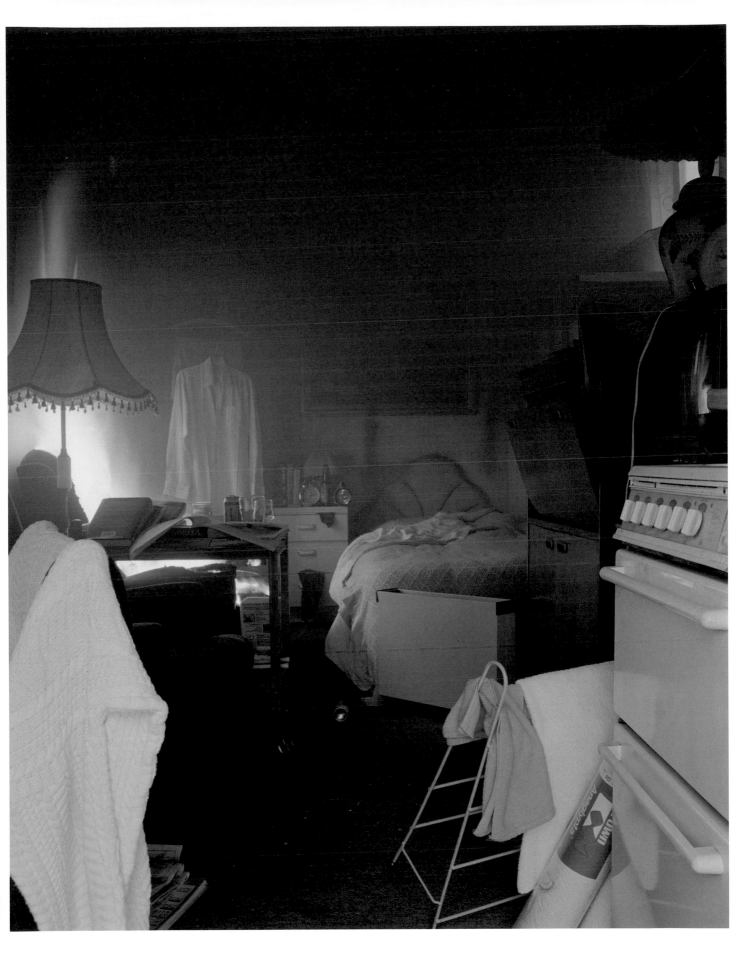

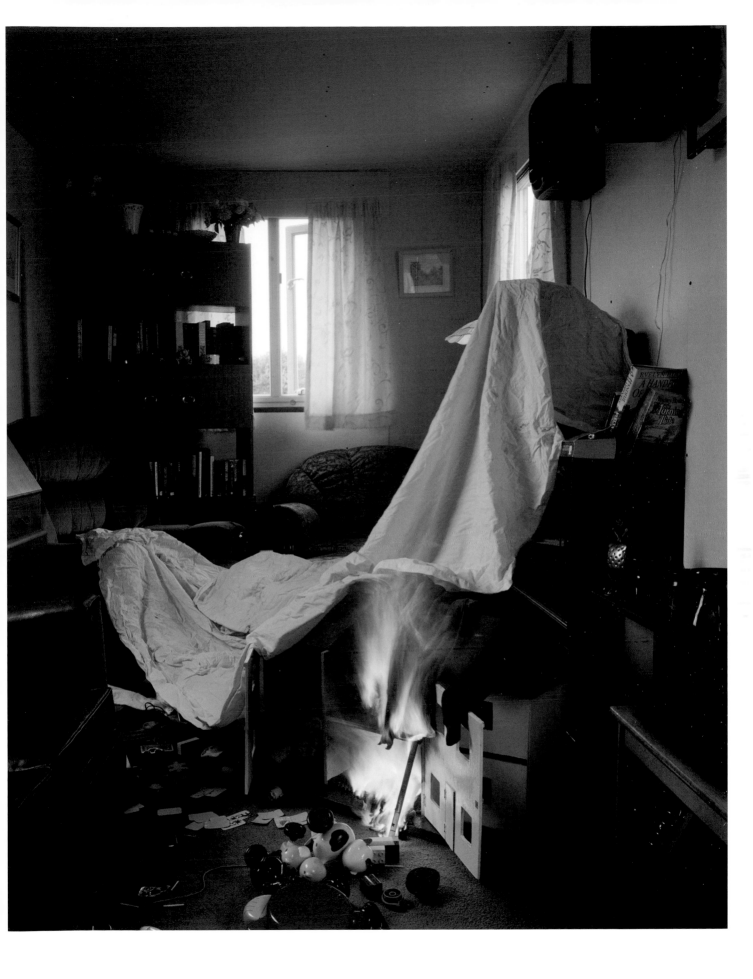

INCIDENT

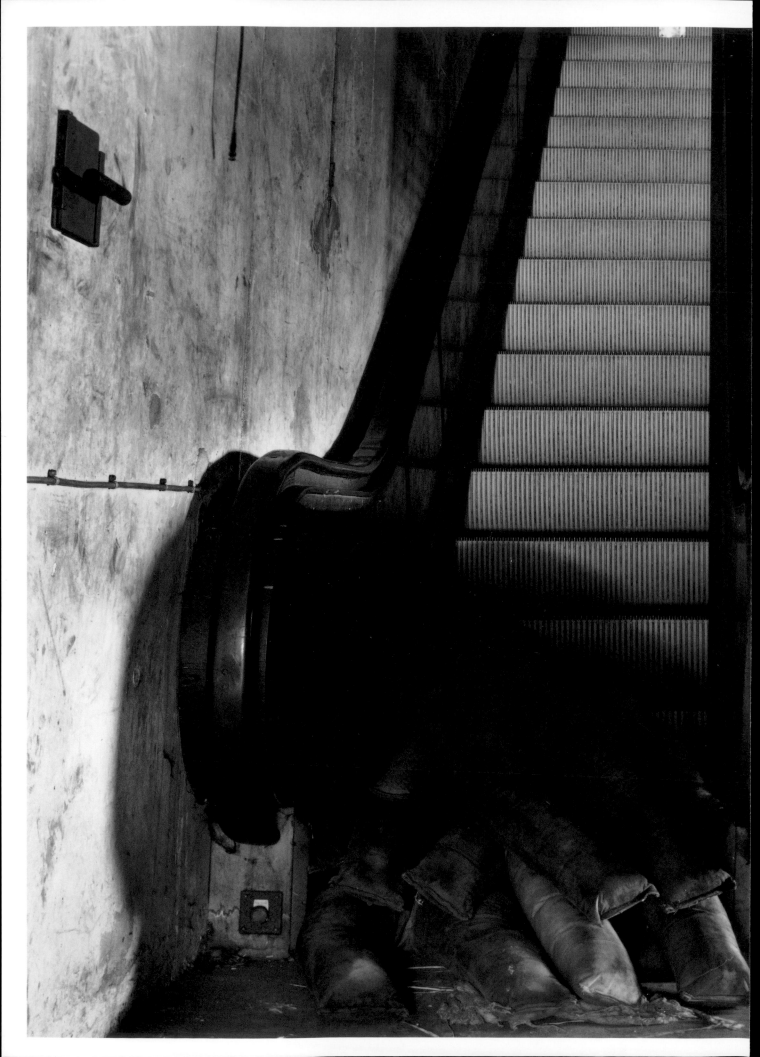

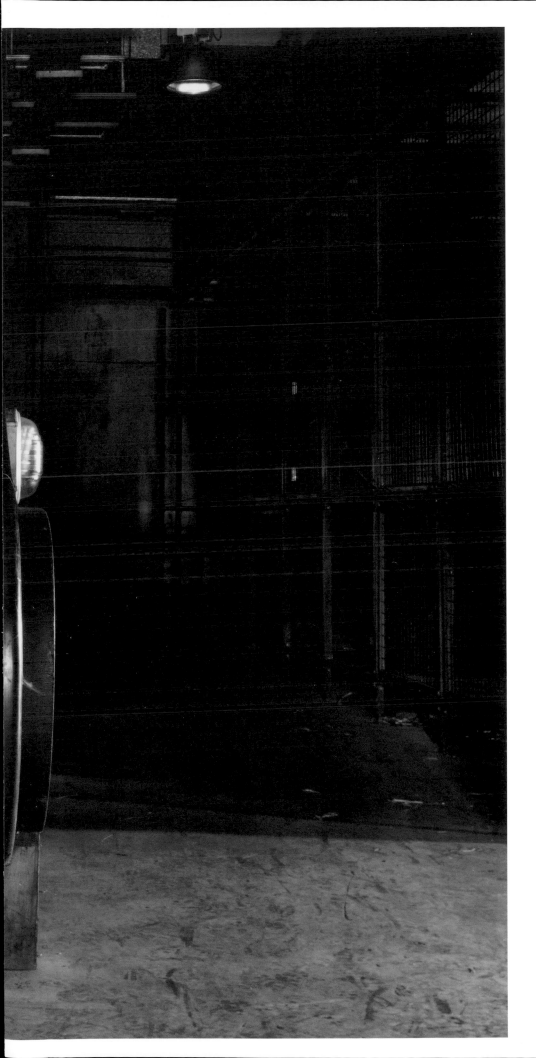

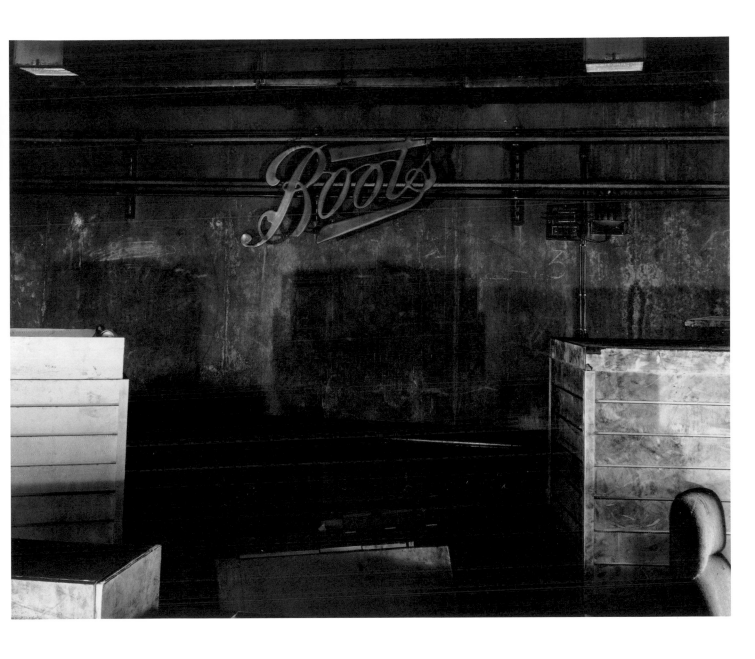

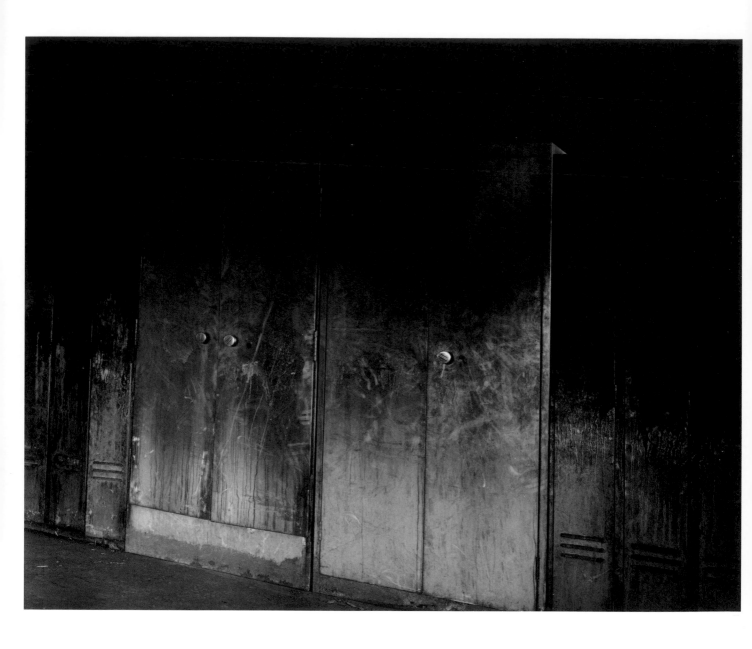

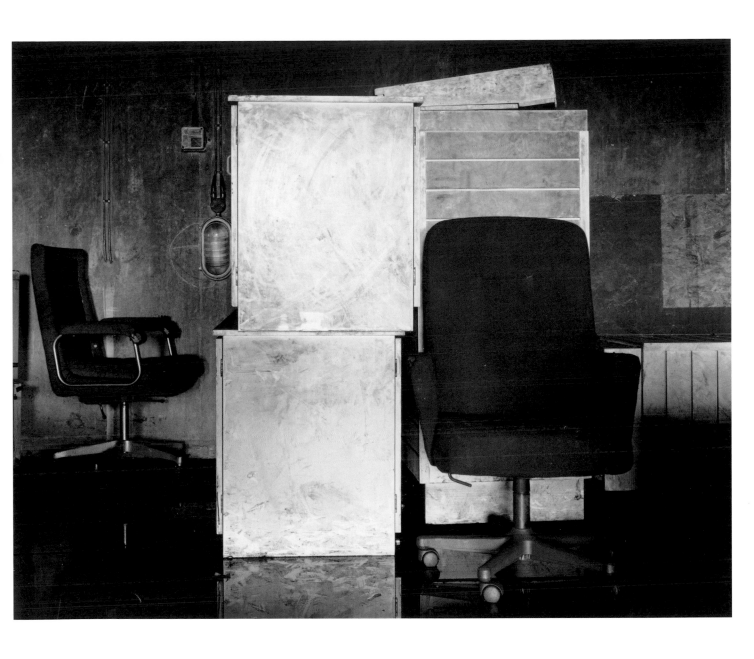

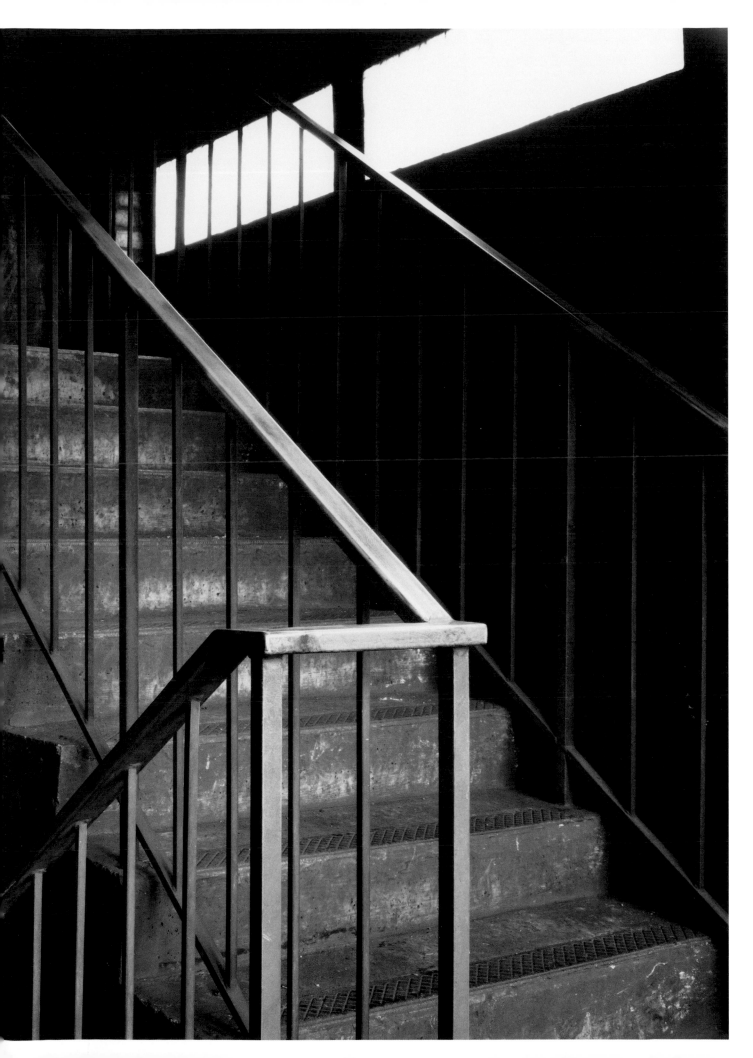

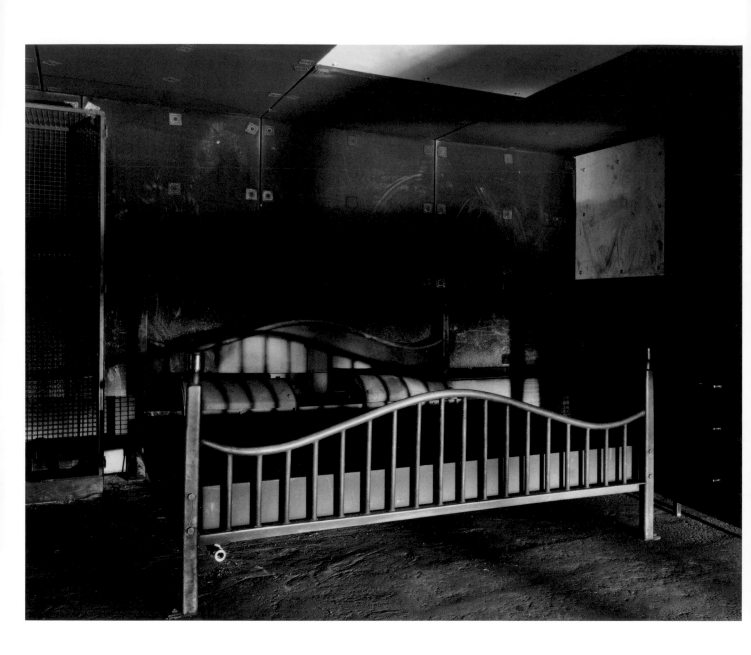

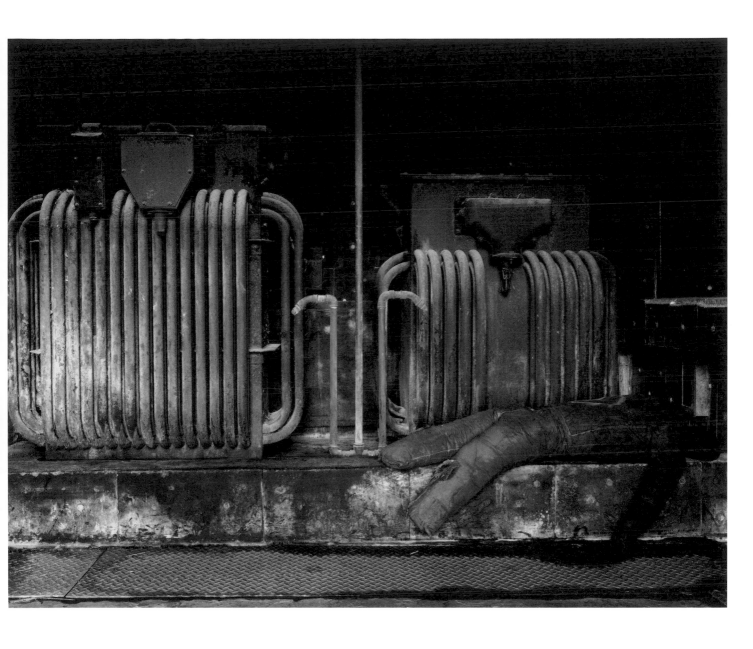

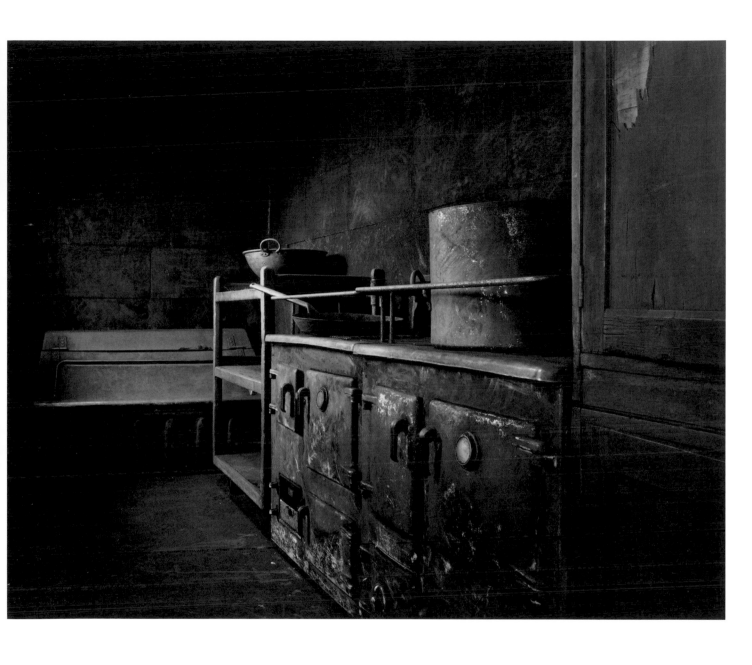

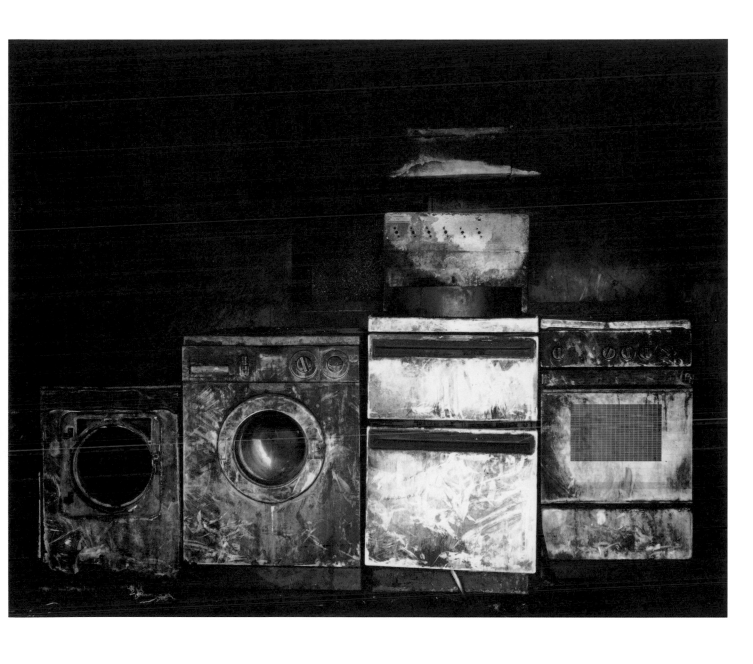

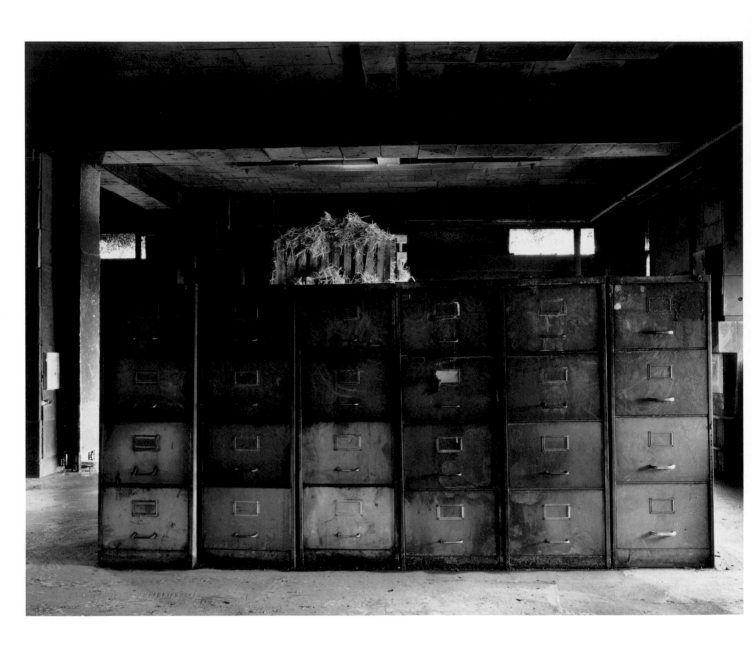

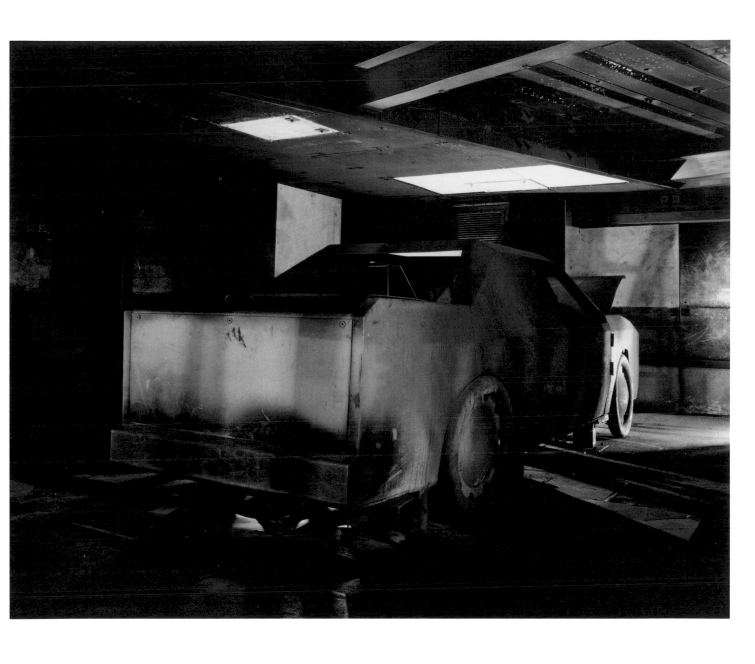

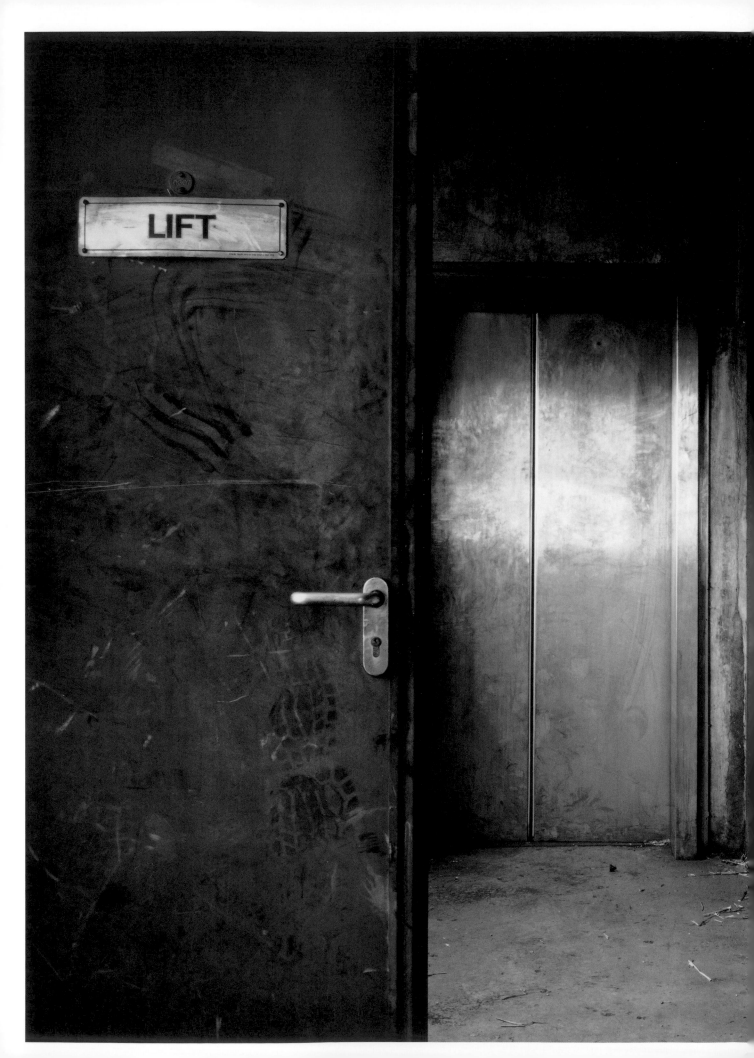

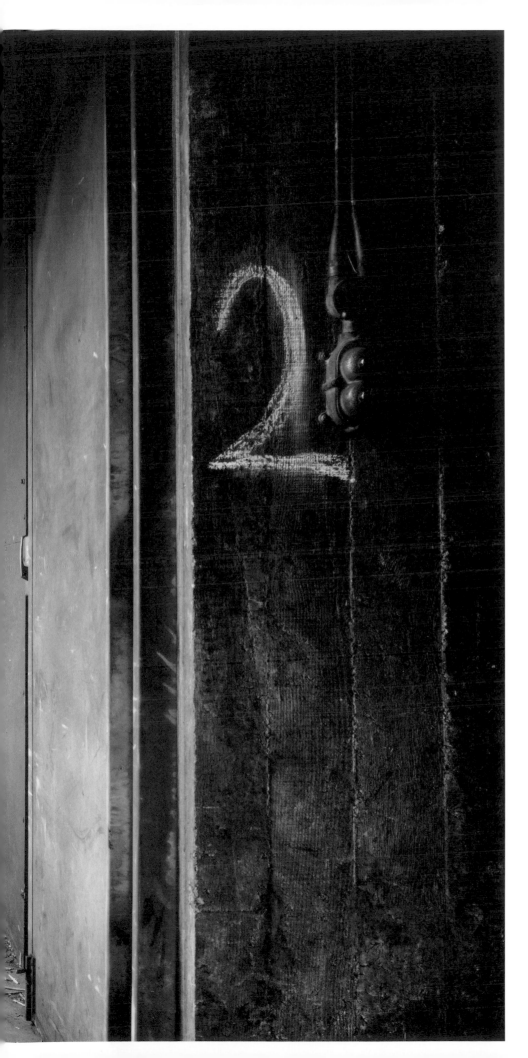

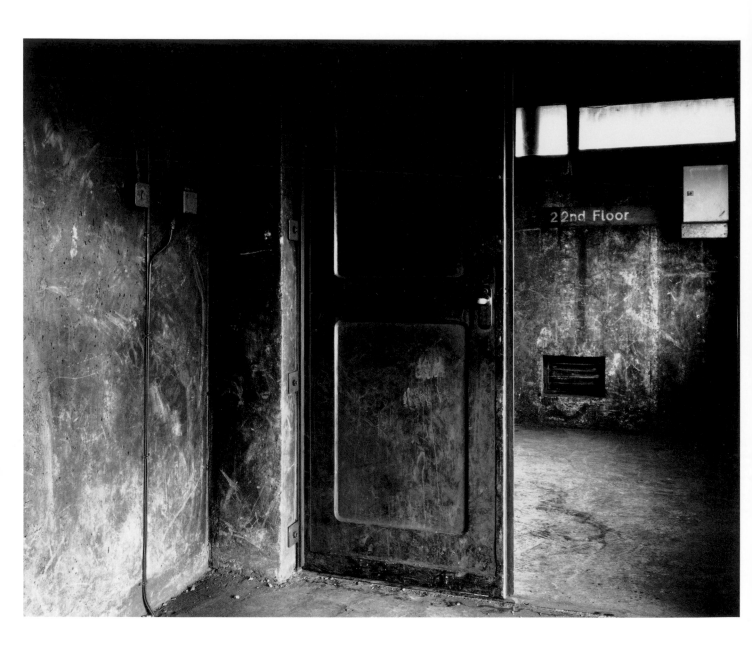

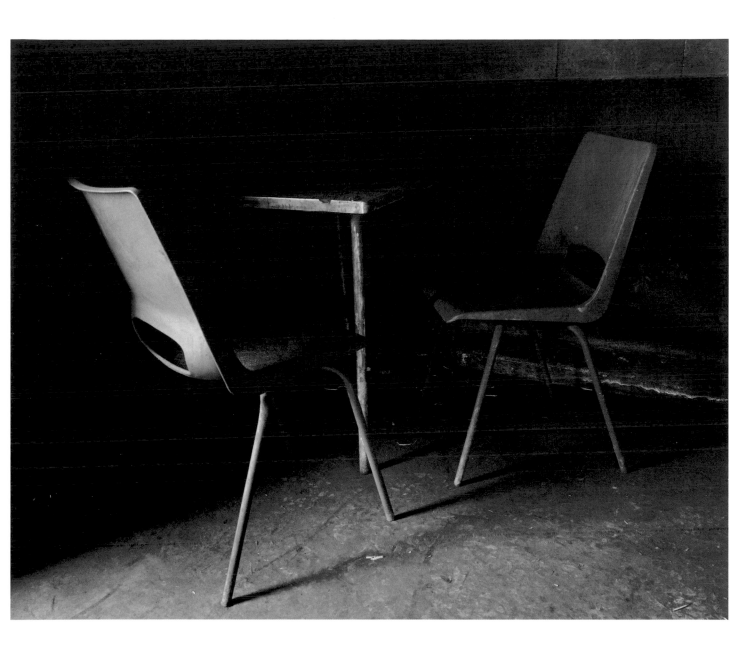

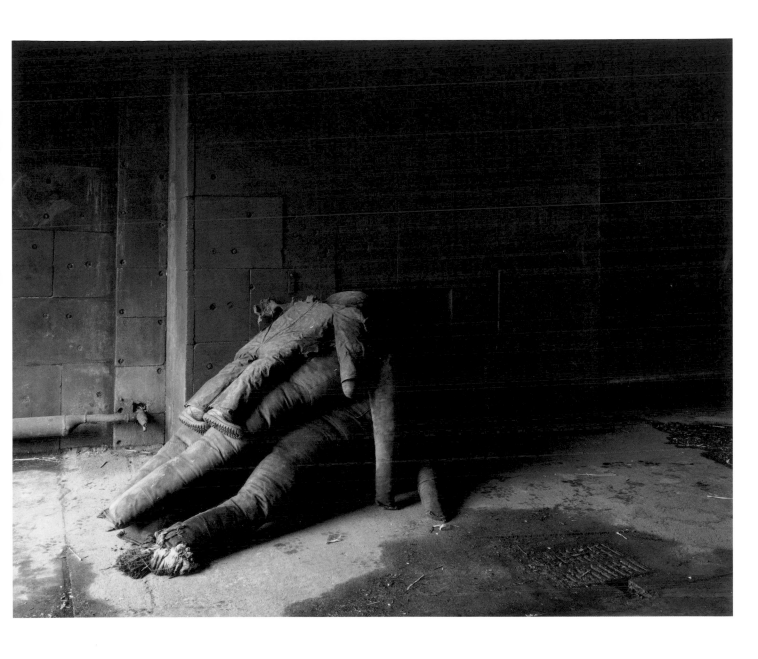

aperture foundation

Aperture is a not-for-profit foundation dedicated to promoting photography in all its forms through our award-winning *Aperture* magazine, books, limited-edition photographs, and traveling exhibitions.

To join our mailing list, please complete and return this card. You'll receive Aperture's catalogs, plus, if you sign up for our email newsletter, advance notice of special events and web-exclusive discounts.

NAME

ADDRESS 1

ADDRESS 2

CITY _____ STATE _____ ZIP _____

COUNTRY

EMAIL (FOR NEWSLETTER)

ARE YOU AN APERTURE MAGAZINE SUBSCRIBER?

aperture

PO BOX 3000

DENVILLE, NJ 07834

Visit us online at

www.aperture.org

SARAH PICKERING

born 1972, Durham, UK

EDUCATION

2005 Master of arts, photography, Royal College of Art, London
1995 Bachelor of arts, photographic studies, University of Derby
1992 Foundation certificate in art and design, Newcastle College

SELECTED SOLO EXHIBITIONS

2010

Sarah Pickering—Incident Control, Museum of Contemporary Photography, Columbia College Chicago

2009

Holding Fire, Ffotogallery, Penarth, Wales
Explosion, Meessen De Clercq, Brussels

2008

Incident, Phoenix Gallery, Brighton, UK
Fire Scene, Daniel Cooney Fine Art, New York

2007

Explosion, Photographers' Gallery Print Room, London

2006

Sarah Pickering, PynerContreras, Cultural Fair, Mexico City
Explosion, Daniel Cooney Fine Art, New York

SELECTED GROUP EXHIBITIONS

2009

Manmade: Notions of Landscape from the Lannan Collection, New Mexico Museum of Art, Santa Fe
Manipulating Reality, Centro di Cultura Contemporanea Strozzina, Fondazione Palazzo Strozzi, Florence
Photography collection installation, Victoria and Albert Museum, London

Totale Erinnerung, Fotofestival Mannheim, Germany
Theatres of the Real, Fotomuseum, Antwerp, Belgium

2008

Rethinking Landscape: Photography from the Allen G. Thomas Jr. Collection, Taubman Museum of Art, Roanoke, Virginia
Collisions, Maison du Danemark, Paris
New Typologies, New York Photo Festival
In Our World. New Photography in Britain, Galleria Civica di Modena, Italy
Blown Away, Krannert Art Museum, Champaign, Illinois

2007

Contemporary, Cool and Collected, Mint Museum of Art, Charlotte, North Carolina
How We Are: Photographing Britain, Tate Britain, London
The Big Picture, North Carolina Museum of Art, Raleigh
System Error, Palazzo delle Papesse, Siena, Italy

2006

War Fare, Museum of Contemporary Photography, Columbia College Chicago
The Universe in a Handkerchief, Gallery Yujiro, London
Shifting Terrain, Herter Gallery, University of Massachusetts, Amherst
PLUG, White Space, County Hall Gallery, London

2005

Jerwood Photography Award touring exhibition, UK
Sarah Pickering & Gonzalo Lebrija, PynerContreras, London
EAST International, Norwich, UK
The Show: One, Royal College of Art, London

2004

Timeshare, Trinity Buoy Wharf, London
Made in London, European Parliament, Brussels

1999

West Midlands Arts Portfolio Award Winners showcase, Midlands Art Centre, Birmingham, UK

SELECTED BOOKS AND EXHIBITION CATALOGS

Barnes, Martin, and Roanne Dods. *New Light.* Jerwood Award winners catalog. Edinburgh: *Portfolio Magazine,* 2009.

Bingham, Georganne, David J. Brown, and Dennis Weller. *Rethinking Landscape: Photography from the Allen G. Thomas Jr. Collection.* Roanoke, Virginia: Taubman Museum of Art, 2008.

Demos, TJ. *Vitamin Ph: New Perspectives in Photography.* London: Phaidon, 2006.

Duggan, Ginger Gregg, and Judith Hoos Fox. *Blown Away.* Champaign, Illinois: Krannert Art Museum, 2008.

Fusi, Lorenzo, and Naeem Mohaiemen. *System Error: War Is a Force That Gives Us Meaning.* Milan: Silvana Editoriale, 2007.

Hanzal, Carla M., and Robert Hobbs. *Contemporary, Cool and Collected.* Charlotte, North Carolina: Mint Museum of Art, 2007.

Lowry, Joanna, David Green, and Jan Baetens. *Theatres of the Real.* Antwerp and Brighton: Fotomuseum Antwerp and Photoworks, 2009.

Maggia, Filippo. *New Photography in Britain.* Milan: Skira, 2008.

Nori, Franziska, ed. *Manipulating Reality.* Florence: Centro di Cultura Contemporanea Strozzina & Alias Publishing, 2009.

Parr, Martin. *New York Photo Festival 2008 Catalogue.* Brooklyn: powerHouse, 2008.

Williams, Val, Susan Bright, and Martin Parr. *How We Are: Photographing Britain.* London: Tate Publishing, 2007.

SELECTED ARTICLES AND REVIEWS

"50 Significant Artist Photographers in the UK," *Portfolio Magazine,* Issue 50, November 2009.

"In Training," Jesse Alexander, *Source Magazine,* Issue 60, Autumn 2009.

"The Victoria and Albert Museum," *C Photography International,* Issue 9, 2009.

"Fire Scene," interview with Anthony Luvera, *Hotshoe International,* April–May 2009.

"Incident" and "Fade to Black," Jason Evans, *Photoworks,* Issue 11, October 2008.

"Talent, Fire Scene," interview with Anne-Celine Jaeger, *FOAM* #16, Fall 2008.

"Sarah Pickering," Vince Aletti, *New Yorker,* March 10, 2008.

"Sarah Pickering," Nicole Rudick, *Artforum,* March 2008.

"Sarah Pickering: 'Fire Scene,'" Karen Rosenberg, *New York Times,* February 8, 2008.

"We Are Here," Martin Parr, Anna Pavord, and David Campany, *Tate etc.,* Summer 2007.

Prefix Photo, Issue 15, May 2007.

"Explosions," interview with Warren Howard, *Independent,* April 5, 2007.

"War Photography: Beyond Documentary," Richard B. Woodward, *ARTnews,* March 2007.

"Explosions," Brian Dillon, *Art Review,* February 2007.

"Artist Project/Explosion," *Cabinet,* July 2006.

"Sarah Pickering: Explosion," John Slyce, *Portfolio,* Issue 43, May 2006.

"Blow Up: Explosions," *Seesaw Magazine,* Spring 2006, www.seesawmagazine.com.

"Up In Smoke: An Explosive Approach to Art," Blake Gopnik, *Washington Post,* January 15, 2006.

"Napalm With a Side of Fuel Air Explosion," Amy Benfer, *Metro New York,* January 10, 2006.

"Sarah Pickering," Nicole Rudick, *Artforum* online, January–February 2006.

"The Best Emerging Photographers of 2005," *Art Review,* October 2005.

PERMANENT COLLECTIONS

Lannan Foundation
Mark Haukohl Collection of Contemporary European Female Photographers
Museum of Contemporary Photography at Columbia College Chicago
North Carolina Museum of Art, Raleigh
Photographers' Gallery, London
Royal College of Art, London
Victoria and Albert Museum, London
Wilson Centre for Photography, London

SARAH PICKERING WOULD LIKE TO THANK:

Greg Jones—for your patience, enthusiasm, inspiration, and understanding

Martin Barnes, Susan Bright, Susanna Brown, Susan Butler, David Campany, David Chandler, Gerardo Contreras, Daniel Cooney, Chris Coppock, Adrian Davies, Jan De Clercq, David Drake, Jason Evans, Anna Fox, Ashley Givens, Vic Johnson, Derek Jones, Sandra Jones, Peter Kennard, Patrick Lannan, Carrie Levy, Gordon MacDonald, Christie Mazuera Davis, Olivier Meessen, Anne Pickering, Brian Pickering, Wendy Pickering, James Pyner, Russell Roberts, Olivier Richon, Allen Thomas Jr., Marta Weiss, Val Williams, Meessen De Clercq Gallery, Brussels, and my family and friends for their support along the way

Fire Service & Fire Service College: including Stephen Andrews, Vince Arthurs, Jim Buckley, Pat Cox, George Curry, Ceri Darrell, Cliff Faulkner, Matt Hall, Brian Harvey, Mark Mason, Garreth Murrell, Pippa, Jonathan Stewart

Metropolitan Police, GMP & PSNI: Roy Darragh, Bob Gallagher, Chief Inspector Dean Higgins, Robert Hughes; Superintendent Alan King, Metropolitan Police Service, Central Operations; Chief Superintendant John O'Hare, Divisional Commander, Rochdale Division

Pyrotechnics: Gary Braim, Tony Lewis, Nick Lewis, Tom Owen, Primetake, Dale Rowson, Peter Stagg, Duncan Thomas

Staff and students at The Slade, UCL, including Martin John Callanan, Michael Duffy, Mick Farrell, John Hilliard, Patrick Ward

Staff at Powerprint, including: Martin Berry, Andy Garcia, Carole Lee, Brendan McMullan, and Lawrence Payne

The Aperture Foundation and staff, especially Denise Wolff and Michael Famighetti

Karen Irvine and staff at the Museum of Contemporary Photography at Columbia College Chicago

The Lannan Foundation

Peter S. Reed Award

Digital color correction by Greg Jones

Front cover: *Land Mine*, 2005
Back cover: *Behind Flicks Nightclub*, 2004
Endpaper: *Disorder Model*, adapted from
Public Order Training and Tactics, 2005

Editor: Denise Wolff
Designer: Andrew Sloat
Production: Matthew Pimm

The staff for this book at Aperture Foundation
includes: Juan García de Oteyza, *Executive Director*;
Michael Culoso, *Chief Financial Officer*;
Lesley A. Martin, *Publisher, Books*; Jenny
Goldberg, *Assistant to the Publisher*; Susan Ciccotti,
Senior Text Editor, Books; Nima Etemadi, *Editorial
Assistant*; Francesca Richer, *Design Director*; Inger-
Lise McMillan, *Designer*; Andrea Smith, *Director
of Communications*; Kristian Orozco, *Sales Director*;
Kellie McLaughlin, *Director, Limited-Edition
Photographs*; Maria Laghi, *Director of Development*;
Julia Barber, Emma Hamilton, Matt Minor, and
Ellen Stavro, *Work Scholars*

Explosions, Fires, and Public Order is part of
Aperture Foundation's First Book Initiative to
publish new work by emerging artists.

Published in collaboration with

Columbia College Chicago

The Museum of Contemporary Photography
at Columbia College Chicago and Aperture
Foundation wish to thank the Lannan Foundation
for their support of this publication and its
corresponding exhibition.

With additional support from the British Council.

The professional staff of the MoCP who con-
tributed to this publication are: Rod Slemmons,
Director; Natasha Egan, *Associate Director
and Curator*; Karen Irvine, *Curator and
Manager of Publications*; Jeffrey Arnett, *Manager
of Development and Marketing*; Corinne
Rose, *Manager of Education*; Stephanie Conaway,
Manager of Exhibitions, and Kristen Freeman,
Manager of Collections. For more information
on the MoCP, visit www.mocp.org.

First edition
Printed by CS Graphics in Singapore
10 9 8 7 6 5 4 3 2 1

Library of Congress Control Number: 2009928447

ISBN 978-1-59711-123-2

Aperture Foundation books are available in
North America through:
D.A.P./Distributed Art Publishers
155 Sixth Avenue, 2nd Floor
New York, N.Y. 10013
Phone: (212) 627-1999 / Fax: (212) 627-9484

Aperture Foundation books are distributed outside
North America by:
Thames & Hudson
181A High Holborn
London WC1V 7QX
United Kingdom
Phone: + 44 20 7845 5000 / Fax: + 44 20 7845 5055
Email: sales@thameshudson.co.uk

aperturefoundation
547 West 27th Street
New York, N.Y. 10001
www.aperture.org

The purpose of Aperture Foundation, a non-profit
organization, is to advance photography in all its
forms and to foster the exchange of ideas among
audiences worldwide.